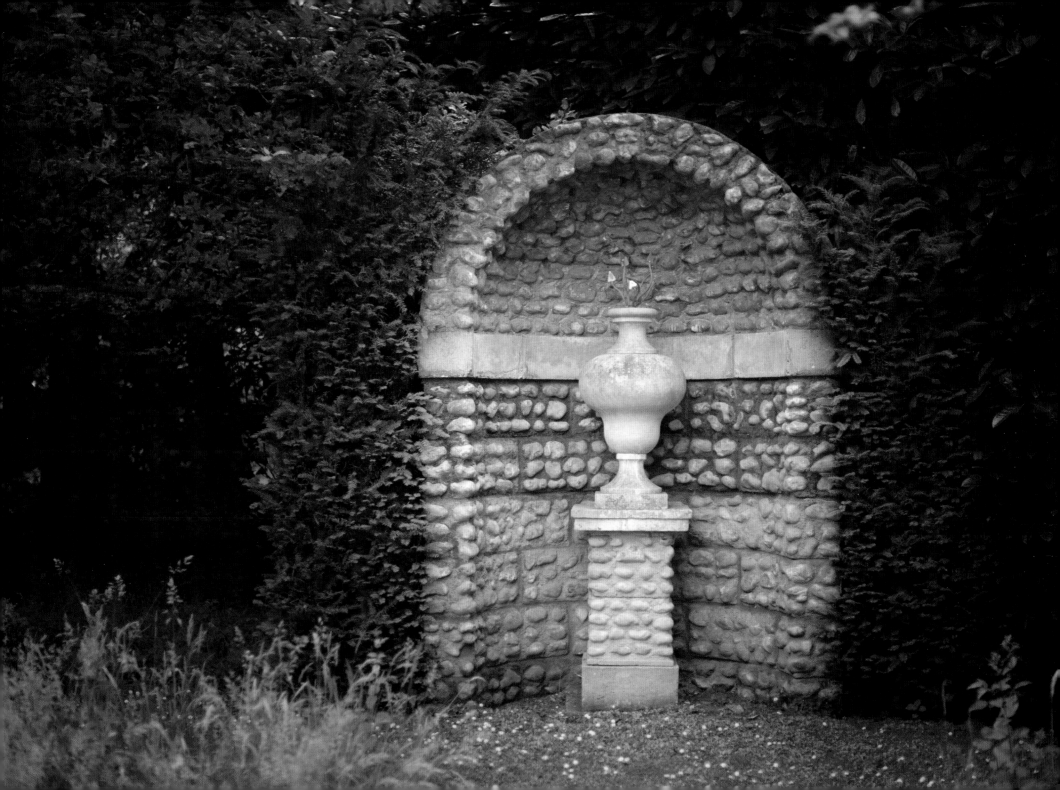

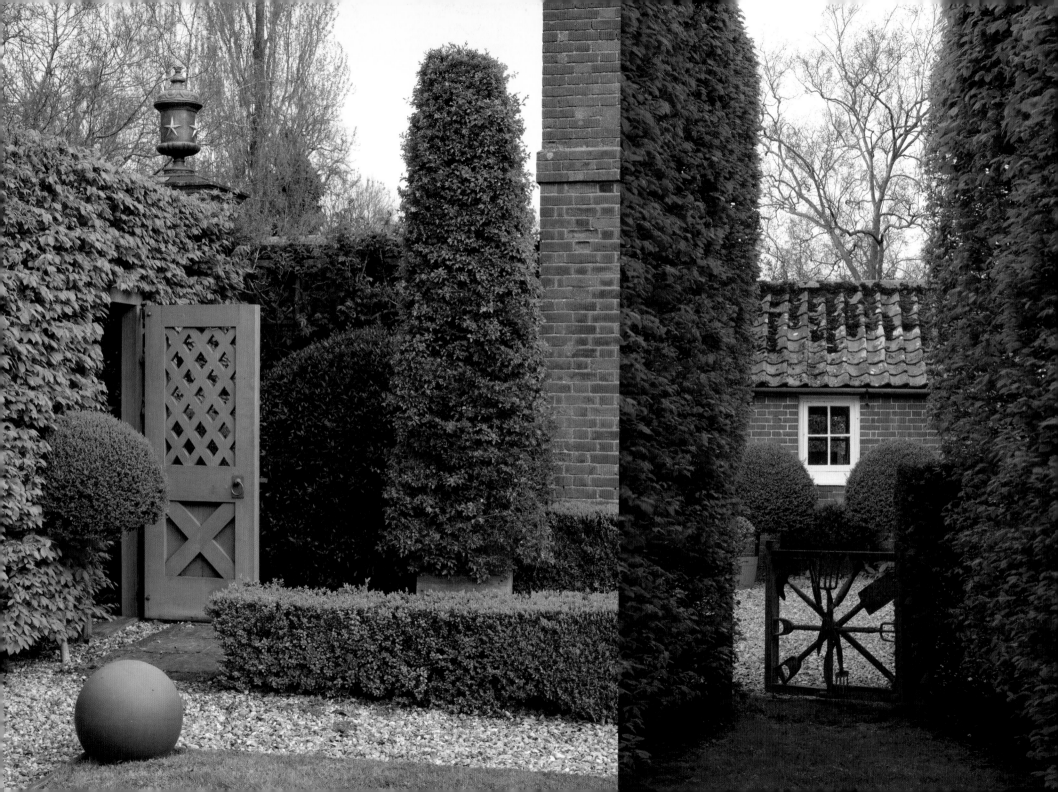

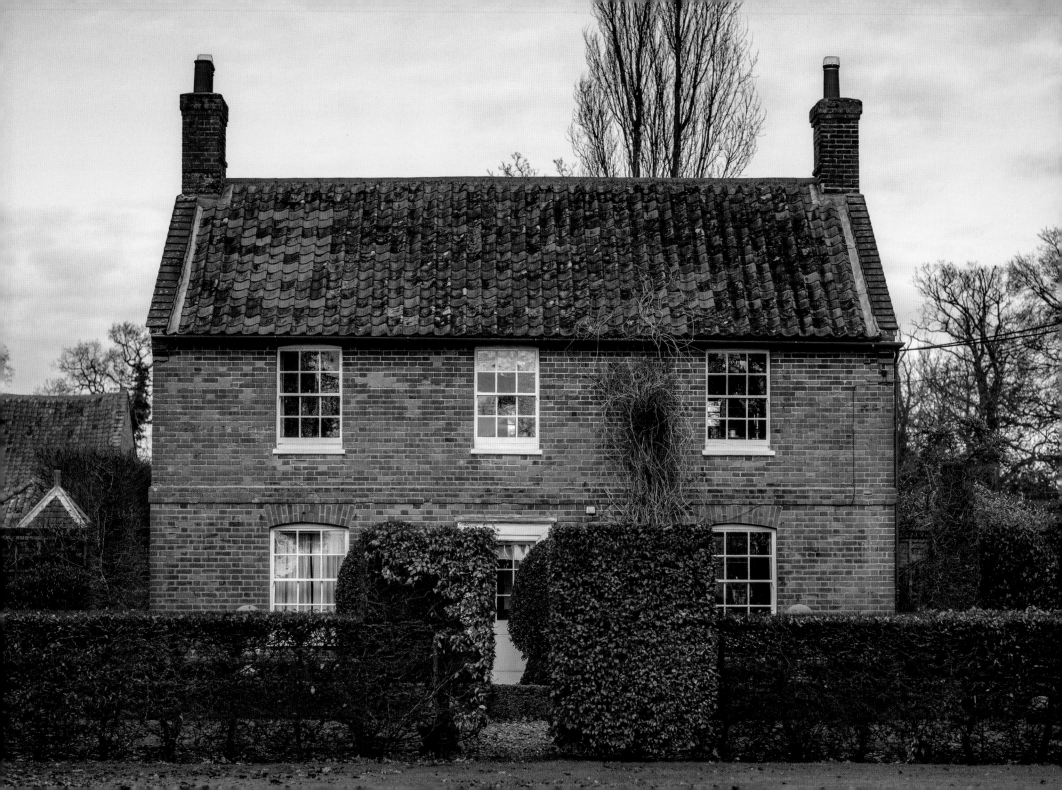

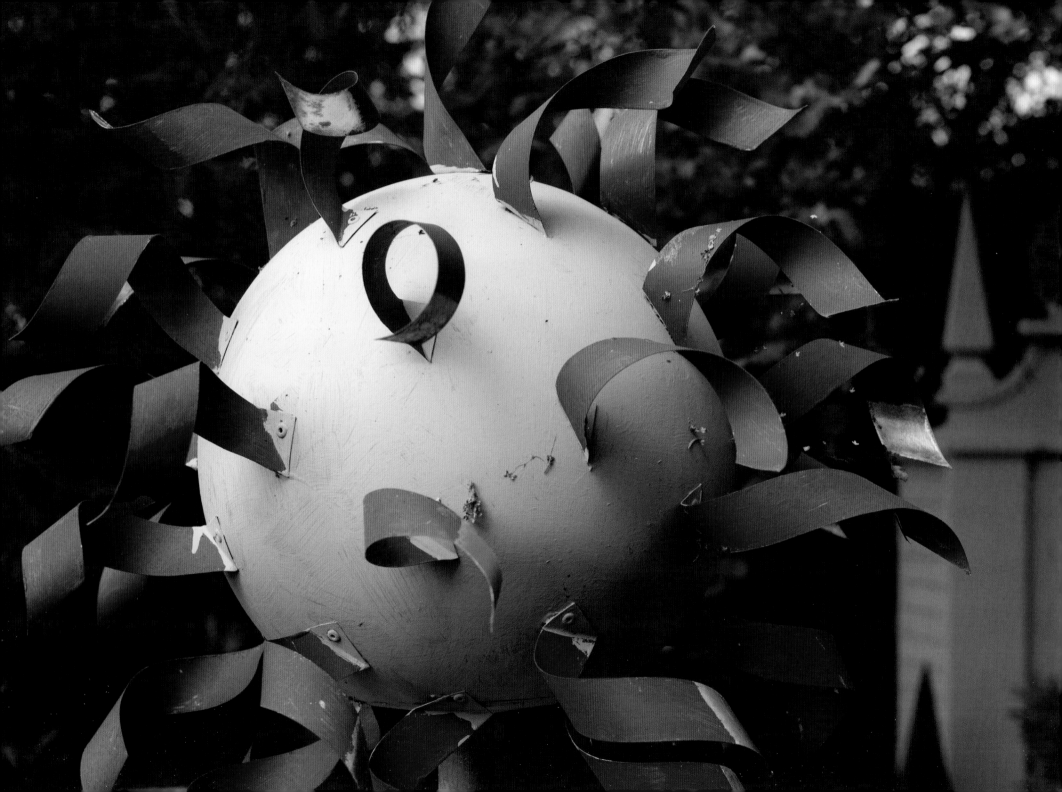

GEORGE CARTER
GARDEN MAGIC
Making the ordinary Extraordinary

Photographs by Harry Cory Wright

Published by Double-Barrelled Books
Double-Barrelled Books
www.double-barrelled-books.com

Editor
Sian Parkhouse

Design
Alfonso Iacurci
Cultureshock Media

Production Manager
Nicola Vanstone
Cultureshock Media

Printed By
Toppan Leefung Pte. Ltd.
www.toppanleefung.com

A CIP catalogue record for this book is
available from the British Library
ISBN: 978-0-9571500-5-8

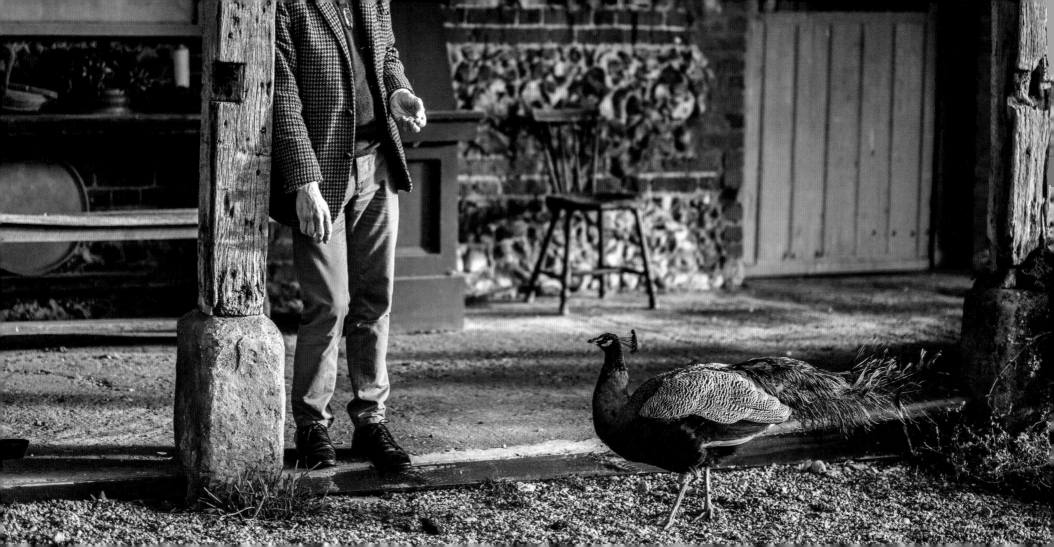

INTRODUCTION

The sublime Norfolk garden of George Carter, garden designer par excellence, which he has created over the past 25 years, both admirably reflects and perfectly crystallises his interest in, and passion for, the art of 17th-century formal garden design; neither a pastiche, nor a copy, the garden at Silverstone Farm is a living and evolving creation, a contemporary version of the traditional formal garden, which is complete in its proportions and balance, beauty and breadth.

The ideas behind the formal garden – symmetry, balance and simplicity – are perfectly attuned to contemporary design thinking, and are perhaps even more apt today when applied to a smaller, modern garden, rather than the large and medium-sized estates where such designs were originally nurtured.

Essential elements of the formal garden have always included such constants as structures, seating, containers and ornament, and George's garden has all these in spades, so to speak. But unlike the

George with Birdy in
front of one of the open
cart sheds.

contents of the original gardens, George, who is a master of lateral thinking, has used skill and ingenuity to create these elements – constructing some himself, adapting others and using surprising finds from such hunting grounds as car boot sales, plumbers' merchants and DIY and garden centres, as well as the odd Christmas decoration.

In this book, every element of the garden is evocatively illustrated with beautiful photographs as well as some of George's own sketches, and George describes in detail not only how he made the garden, and his thinking behind it, but also shows not only how to apply the principles of formal garden design to your own garden, but suggests ways to use your own imagination – to turn a drainage pipe into a plant stand, transform a garden shed into a Gothic show piece and illuminate a piece of water with LED ice cubes. The message is clear: nothing is without merit, always look at alternatives and never underestimate the power of a coat of paint.

— Caroline Clifton-Mogg

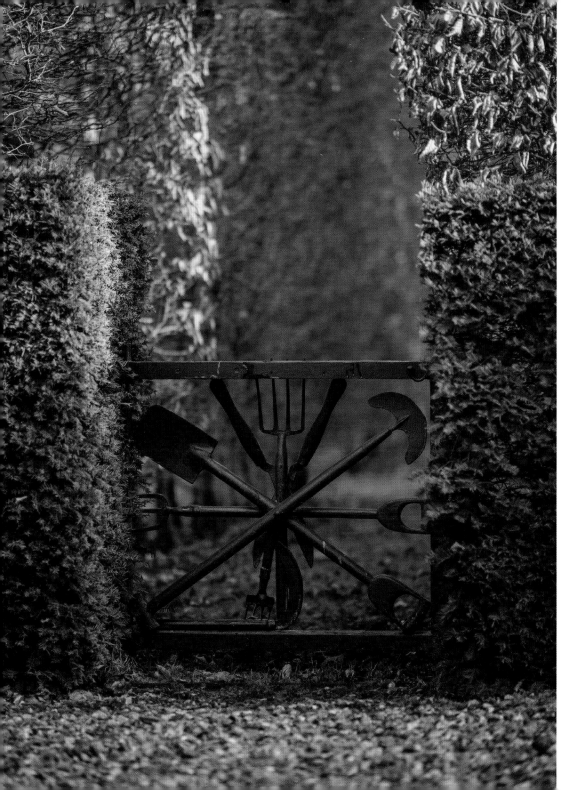

ACKNOWLEDGEMENTS

I would like to thank firstly Caroline Clifton-Mogg and Meredith Etherington-Smith for suggesting the idea of this book and for enormous help in its organisation and production. Harry Cory Wright's photography is both beautifully atmospheric and conjures up the different seasons brilliantly. Brian Turner has made most of the leadwork in the garden, and Peter and Nick Goodwins made many of the objects in the book and many of the garden's features have been made by them over the years - they are never fazed by the most demanding request. Ann Cordery's back up help in many areas has been invaluable.

A gate designed by George and made from old garden tools set into a simple timber frame.

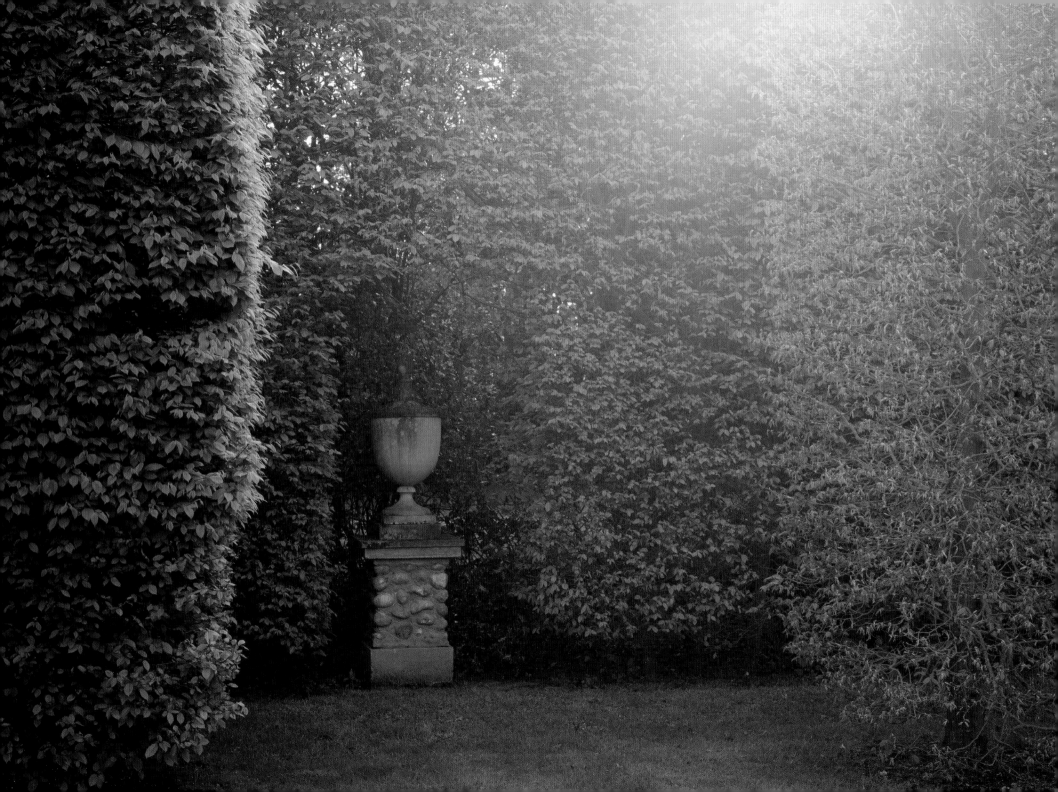

ABOUT THE GARDEN

'I have never had any desire so strong and so like to covetousness as that one which I have had always, That I might be Master at last of a small House and Large Garden, with very moderate Conveniences attached to them, and there dedicate the remainder of my Life only to the Culture of them, and study of Nature.' Abraham Cowley to John Evelyn 1666

I have always admired the formal gardens of the 17th century – their inventive organisation of space, geometry and symmetry. When I bought this house, 25 years ago, I thought it a good opportunity to try to re-invent the traditional formal garden in a contemporary form – to design a garden within the formal tradition, but incorporating some modern elements that were unavailable to gardeners 400 years ago, such as electric light and a wider plant palette. (Although I have tried to stick to a rather small palette here simply because I thought it would be nice to try to recreate an early garden.)

When you start a garden from a blank canvas, it is helpful to have some sort of stimulus – the aspect perhaps, whether it is sunny or shady, the soil type or the layout of the house; something that inspires you or gives you an idea or a clue what to do, that allows you – as Alexander Pope said – to consult the genius of the place.

In the morning sun, a corner of the theatre garden with an urn framed by hornbeam.

9

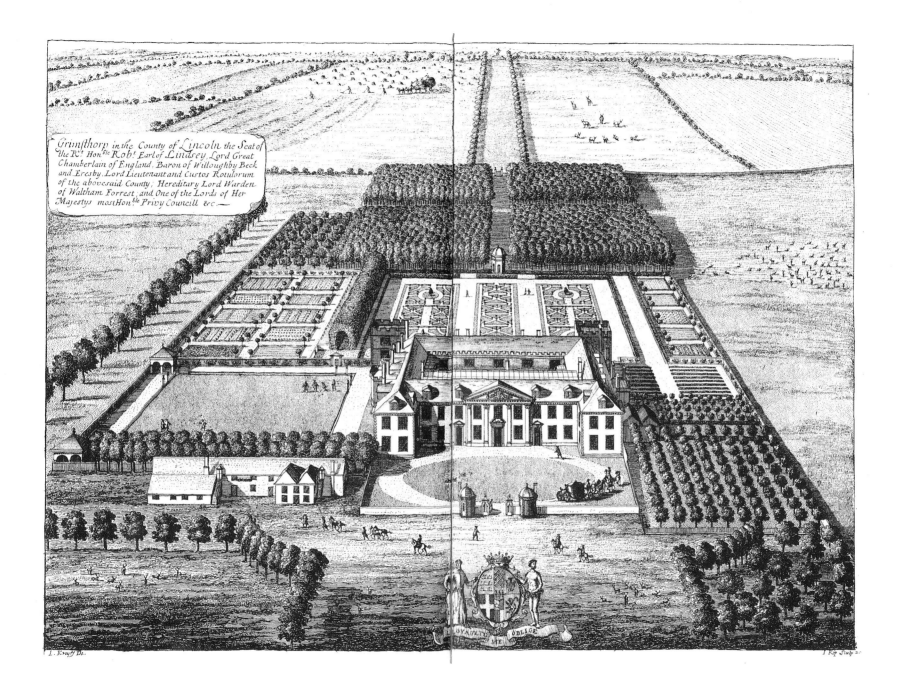

Grimsthorp in the County of Lincoln the Seat of the Rt. Honble Robt. Earl of Lindsey, Lord Great Chamberlain of England, Baron of Willoughby Beck and Eresby, Lord Lieutenant and Custos Rotulorum of the abovesaid County; Hereditary Lord Warden of Waltham Forrest, and One of the Lords of Her Majestys mostHonble Privy Councill &c.

L. Knyff De. I. Kip Sculp.

The house is a small Norfolk farmhouse, surrounded by mature woodland on three sides, which is fairly unusual. Also, and importantly for me, the house is more or less symmetrical. I feel very uncomfortable in an asymmetrical house; I think that the architecture of the house should always be the basis for the architecture of the garden, because you just relate the architecture of the garden to that of the house – the doors and windows acting as the starting point for an axis, a frame or a view-stopper – you just plot where the windows and doors are and start from that.

A Johannes Kip bird's eye view of Grimsthorpe Castle, c.1708 an example of a garden relating closely to the axes of the house.

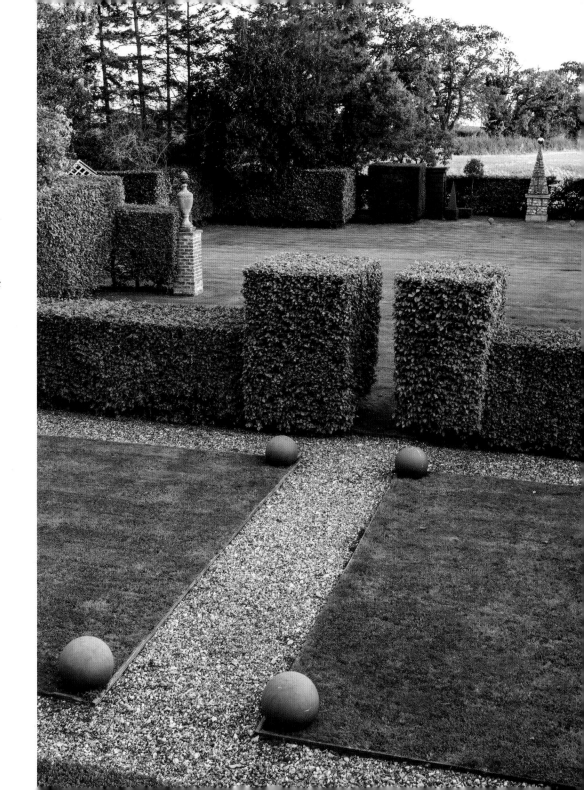

A view through
an arch of trained
hornbeam towards a
stone obelisk.

13

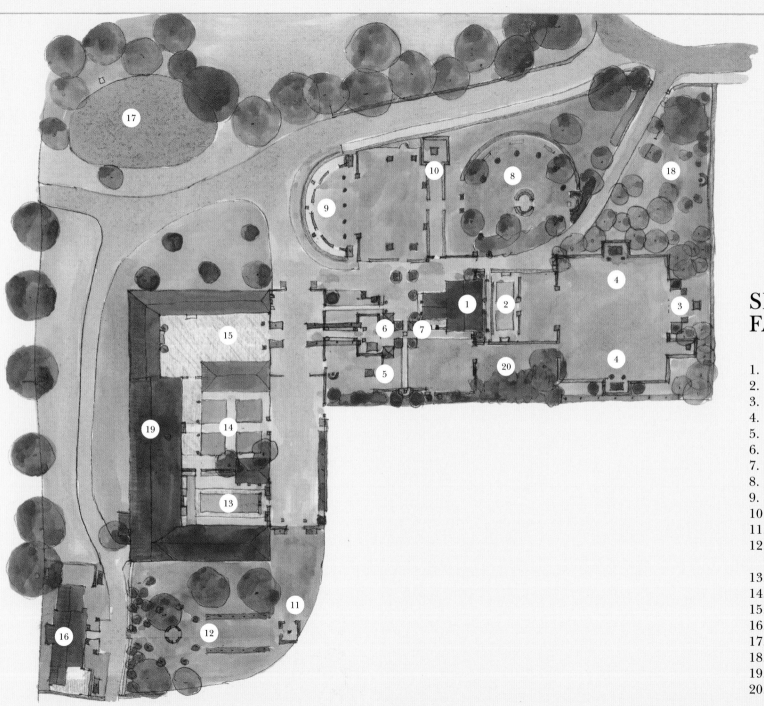

SILVERSTONE
FARM

1. The house
2. The forecourt
3. Obelisk flanked by sentry boxes
4. Pavilions
5. Temple of conscience
6. Twin sheds
7. Herb garden
8. Orchard
9. Green theatre
10. Allée terminating in flint obelisk
11. Obelisk
12. Green temple at the end
 of lime allée
13. Pool garden
14. Grass parterre
15. Workshop yard
16. The engine house
17. Pond
18. Woodland garden
19. Large barn
20. Dark walk

One of the things that makes 17th-century gardens effective is their interest in spatial organisation, volume and void, the way that the wide and the narrow, the long and the short, are contrasted. Some of the engravings contemporary to the period are really very minimal and geometric, almost like Donald Judd sculptures in the 20th century, and I think that 17th-century gardeners got the same pleasure from these contrasts as admirers of the modernist school do now. Then, as now, landscape designers were concerned with contrasts of scale, and in fact many of the 17th-century gardening manuals give you quite useful tips on scale – how wide a terrace should be in relation to the height of the house or how far apart the hedges should be – and other such sensible ideas.

I decided to design the basic architectural structure of the garden through planting – creating hedging and architectural structure with deciduous natives such as hornbeam, beech, oak and limes and then a raft of native evergreens – yew, holly, privet and box – as well as Mediterranean evergreens like *Rhamnus*, laurel – Portugese and cherry – and *Phillyrea*. Topiary was very important in the 17th century, as was pleaching – they topiarised almost everything in sight, from hawthorn to rosemary, and pleaching was practised on many trees such as horse chestnut and hornbeam, while hazel and fruit trees were trained into shapes.

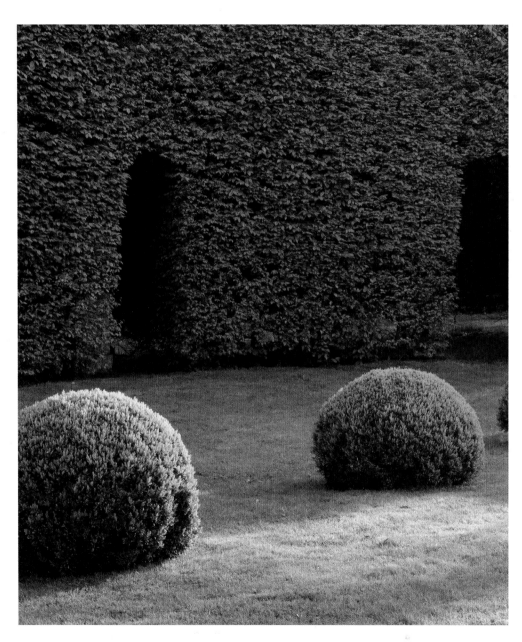

Clipped domes of box in the 'theatre garden' representing footlights.

I drew out the plan of the garden pretty quickly, and planted it pretty quickly, too, using quite small plants. If one wanted quicker results, you could use bigger plants, but I like them to be small – very much as they are in all the engravings and pictures of the period. People obviously planted for posterity then and liked the idea of watching plants grow.

My idea was to recreate a series of forecourts, the sort of thing you might have had leading up to a house in the 17th century, so I started on the south side with what is basically two large spaces and one small space, and then a larger hedged space which is where the tennis court had been. These are framed by various elements, like cubes of yew, wooden sentry boxes and an obelisk, that are all on, or flank, the central axis of the front door.

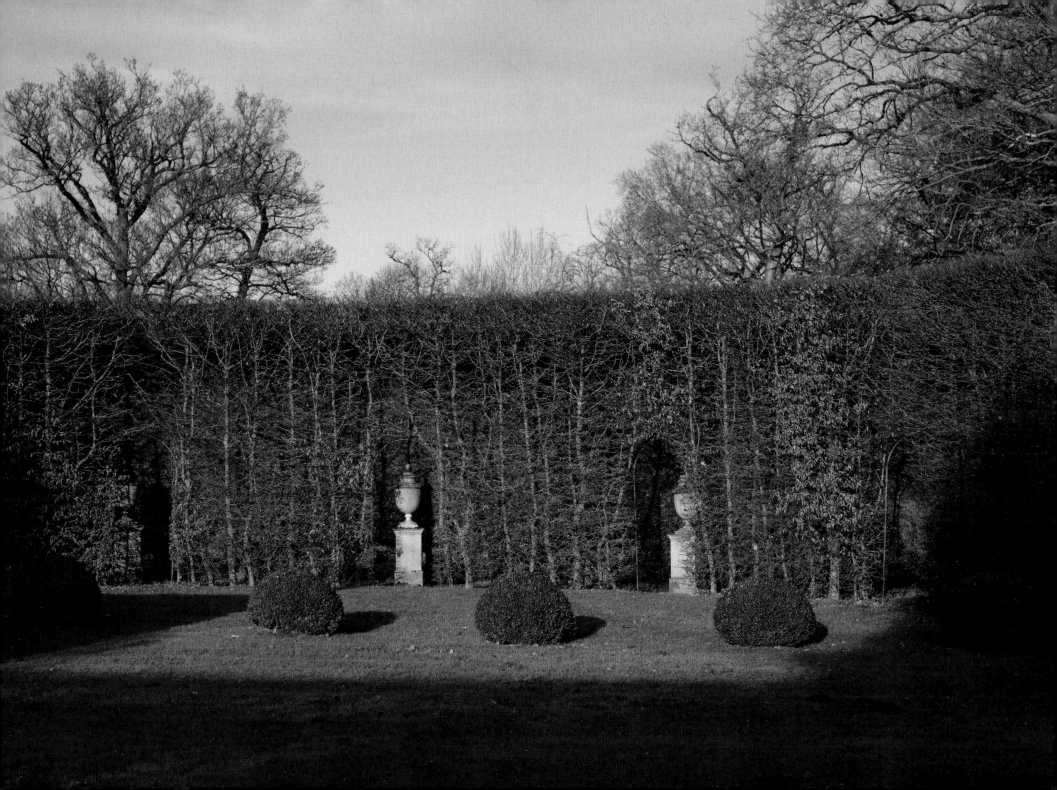

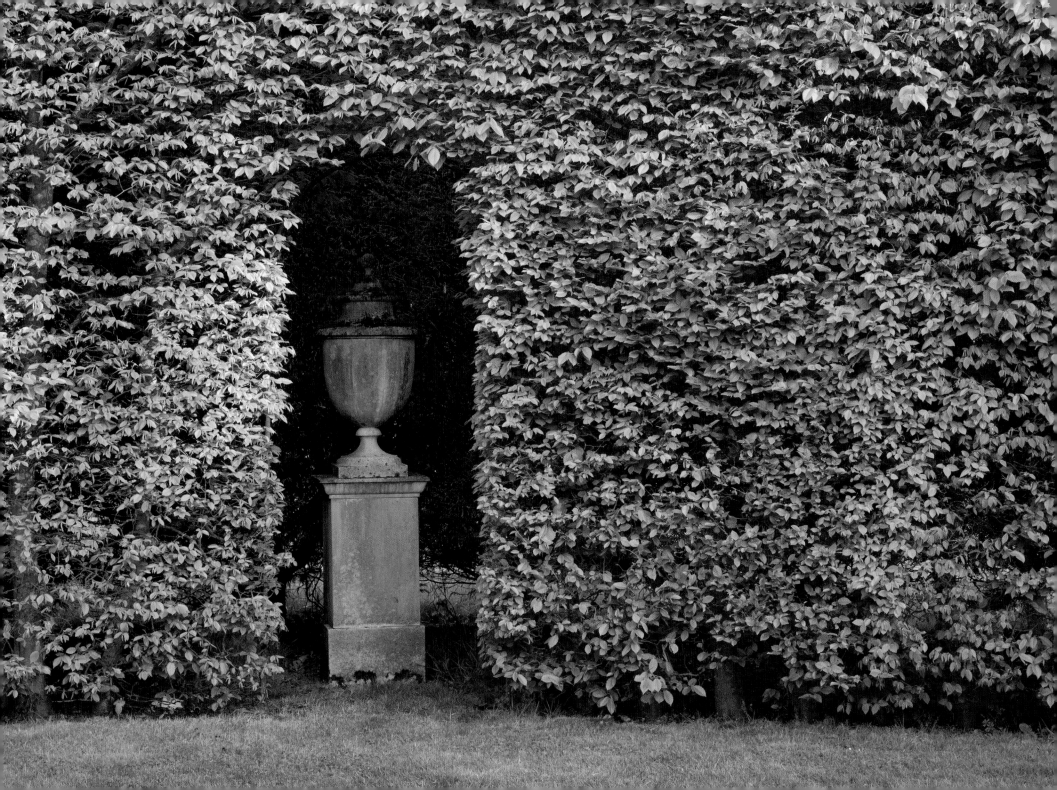

I did utilise some elements of the garden that already existed, such as the shrubbery on the west side as a windbreak, and the small wood on the east side that created a buffer between me and the road. I also retained the two original approaches – to the barns and the front drive; they're not axial, but sometimes the aesthetic has to be tempered by function.

There is quite a lot of garden architecture at work here. Structure and buildings give geometry to a garden, although you do need an element of informality to act as a sort of counterpoint – something to emphasise the formality; here it is the wooded land around the house, which fulfils this function because the wood is completely wild and unstructured.

Two designs by George for cast stone urns – these patinate quickly with age. That on the right is set in a flint niche.

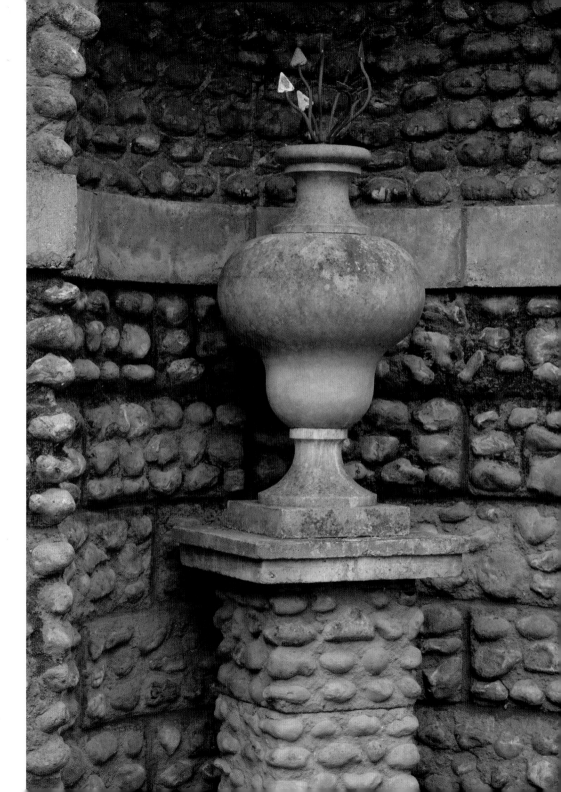

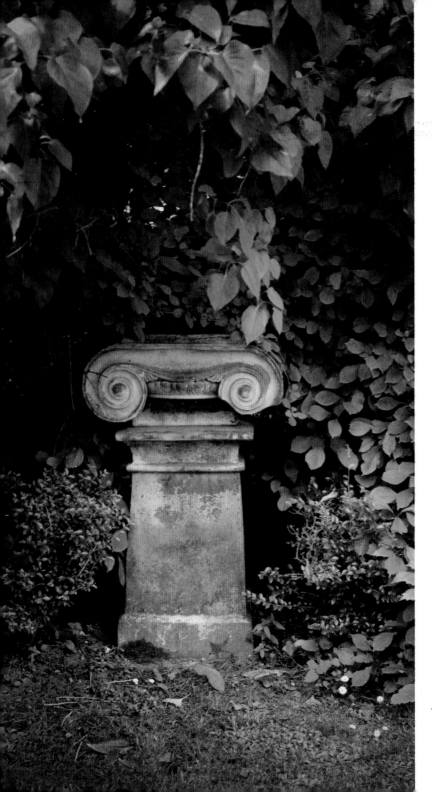

The structured part of the garden is an update of what was called 'carpenters' work', which in the 16th and 17th centuries were the timber frames on which they would structure the gardens – a hedge, for example, would not just be clipped, it would be clipped over a structure. And hedges were often treated as a piece of architecture, with niches cut into them to display pieces of sculpture – again, a niche-shaped timber substructure was behind the hedge. In this garden I used trellis screens behind many of the new hedges – once the hedge had grown, the trellis was removed.

An Ionic capital designed by the northern architect John Dobson is shown on a terracotta chimney pot.

In the orchard short and long grass are contrasted - the box balls are set in a mown strip of short grass.

On the question of colour, because this garden is sculptural I've been trying to eliminate colour, or at least make it subservient to everything else, so the garden is primarily green, although I do allow some colours, such as grey and white. Within the green palette there is a wide variety of colour and texture so they can be used as contrast, and for ground materials I basically used what was there – a lot of gravel and not much paving. I also used grass – materials need not be expensive.

All parts of the garden are structured – either by walls or hedges. On the right a wooden arch frames an urn.

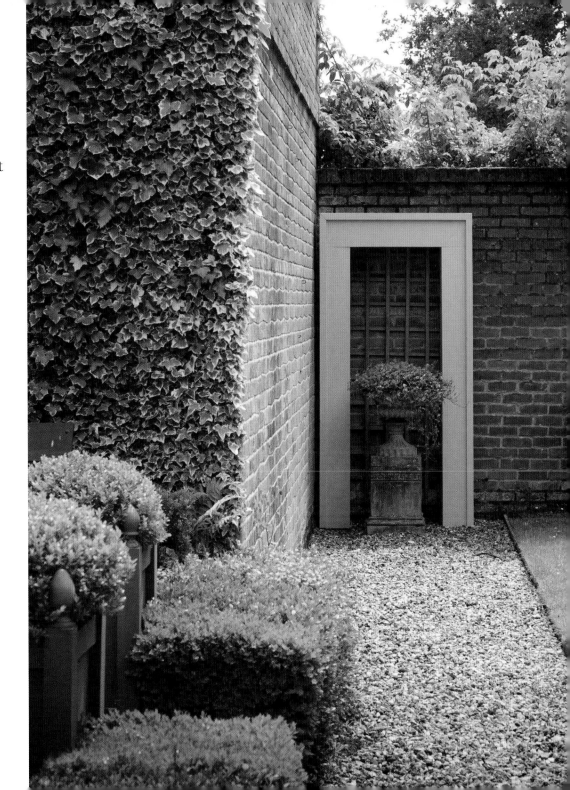

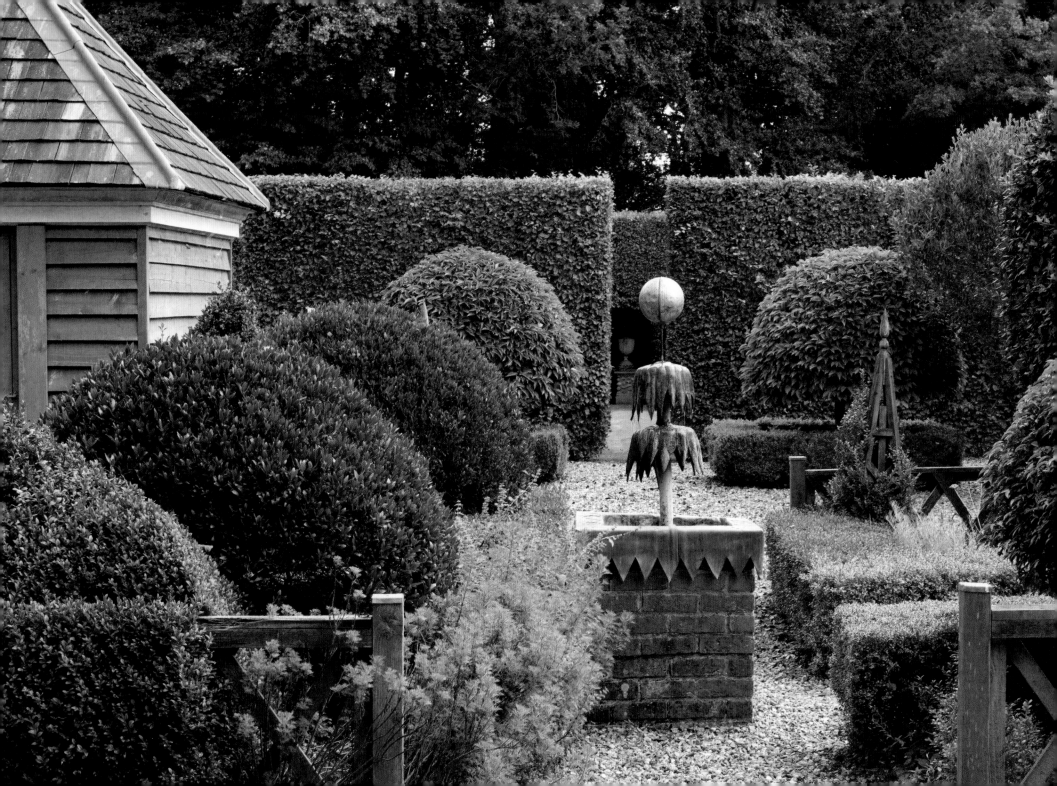

A small fountain with lead frostwork is at the centre of one of the transverse axes that run across the garden. Both ends of this axis are terminated by urns.

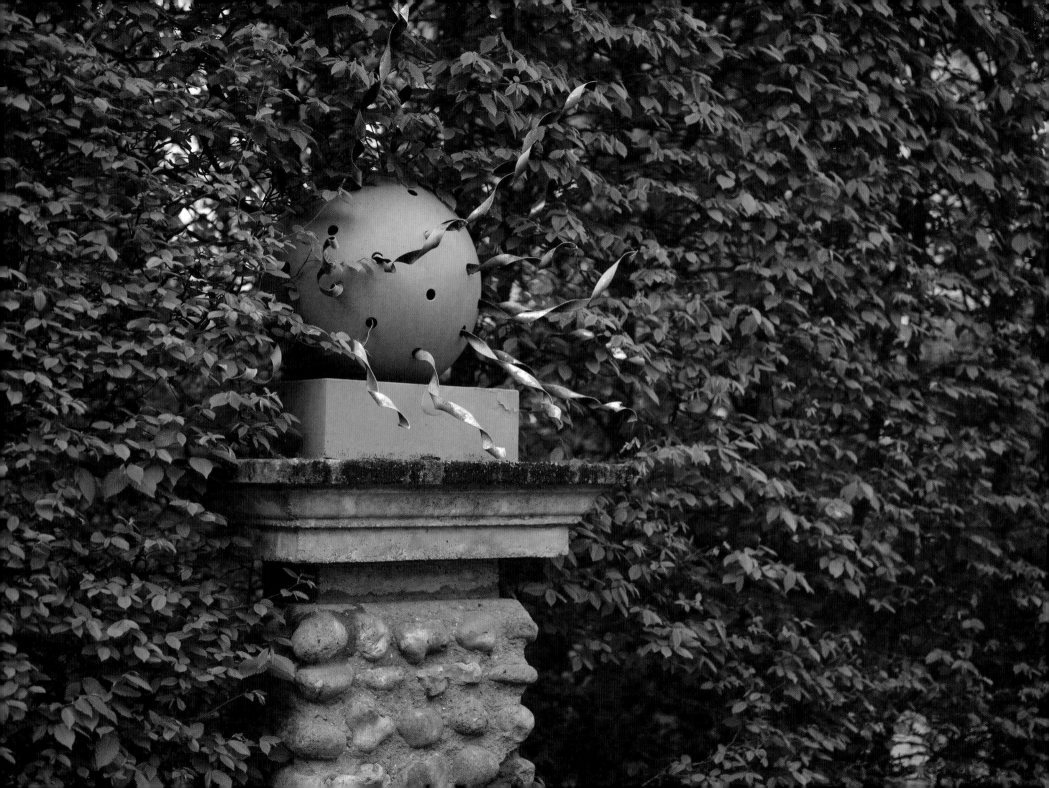

Throughout I've tried to use materials that are indigenous to the area – so no marble, but flint instead. I've also chosen materials that will patinate with age, and tried not to smarten up the buildings externally too much, leaving them pretty much as they were. I think that is an important element of garden design, whatever the style – what Humphry Repton called character; keeping things true to the original.

Fiery balls, painted resin balls and box balls are one of the motifs repeated throughout the garden. On the right a door has been set into a hornbeam hedge.

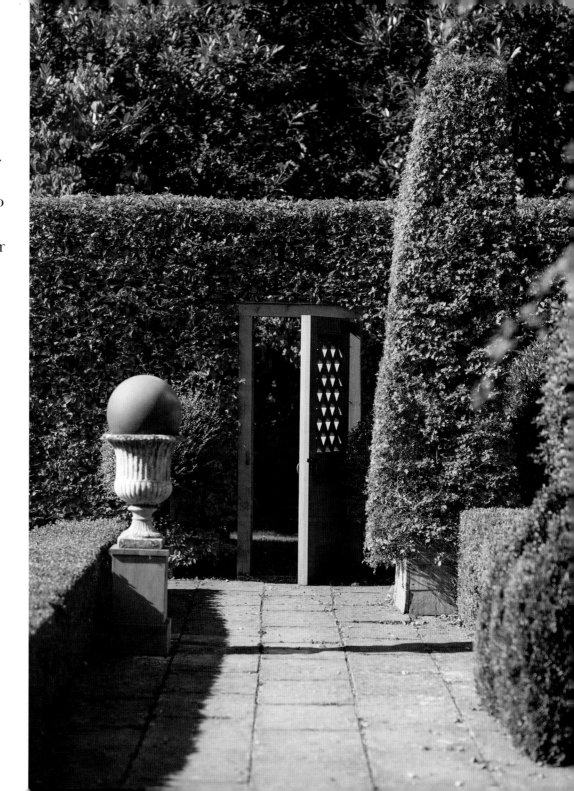

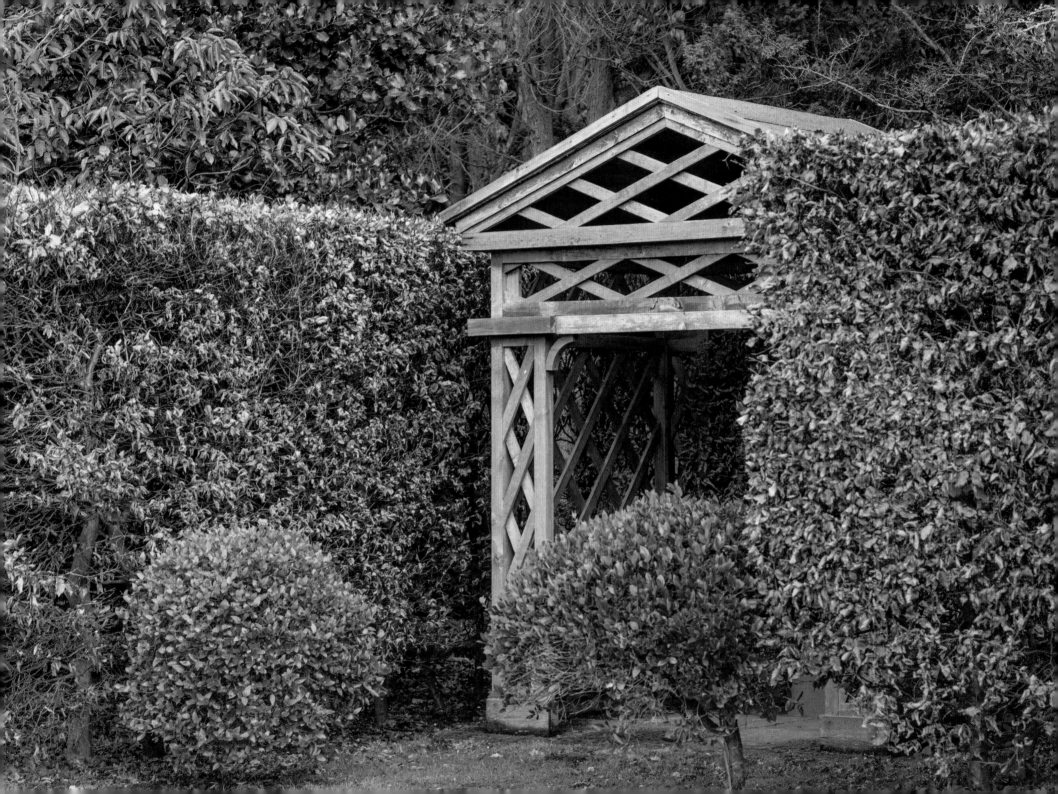

I do think that you shouldn't really have to reinvent every time; it's quite useful to have some rules, and I think that 17th-century pattern books were quite specific about what does and doesn't work. Garden manuals were much wider in their view than many modern ones, giving advice on a range of questions not strictly horticultural. It's good to look back; the history is there with thousands of ideas, all waiting to be ransacked, and it shouldn't be ignored. There's still lots to know – undiscovered history.

The garden now is 25 years old, and what happens with age is that the scale changes and the garden evolves. I like the fact that it's not static, and that the small detail evolves over the years. You add bits and subtract things. Is it finished? No, and I don't think it ever will be.

This simple trellis structure stained a faded blue is set into the recess of a beech hedge with its winter foliage. It is one of a pair set facing East and West across a large lawn.

INTO
THE GARDEN

—

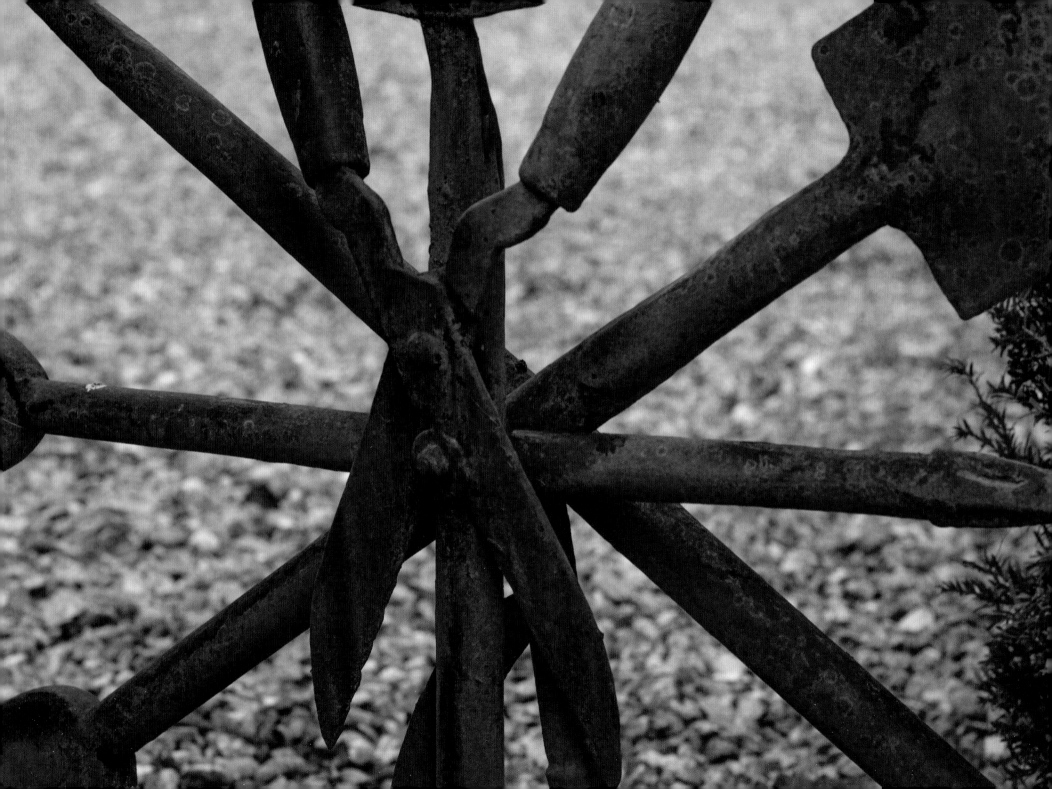

FRAMES

Every garden needs an entrance, and within the garden, a frame – or frames. In a 17th-century formal garden the aim was to create axes and vistas and to do that they had to be defined in some way. It's the same today, whether the garden is a large park or a small garden – although in a small garden, it is particularly relevant because very often there are no viewpoints to focus on, so a frame becomes particularly important. A frame can be many things – something as simple as a gate, a hedge with a gap in it, a pair of trees, or a pair of shrubs, wooden or stone piers, an arch, a pair of sentry boxes, or even a pergola; in fact anything that creates a frame to focus the eye and through which you are looking further into the garden, at a different picture thrown into perspective by the frame.

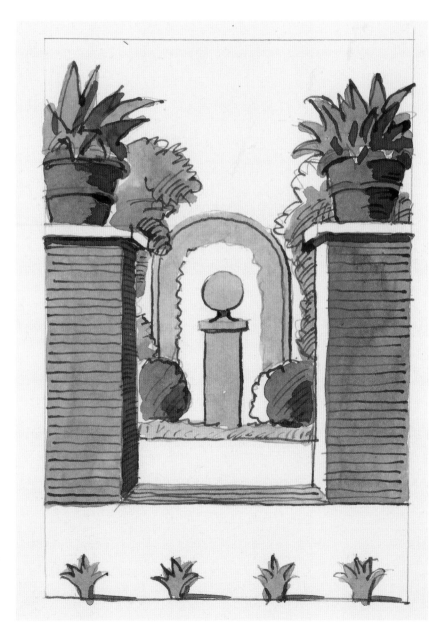

A pair of plain brick piers given importance by sitting large terracotta pots on top of flat cappings. These are planted with agaves or aloes, but you could use fake leaves or even ply cut-outs to create similar bold foliage. The piers are made to frame a ply arch with a simple cut-out ball on a flat cut-out plinth.

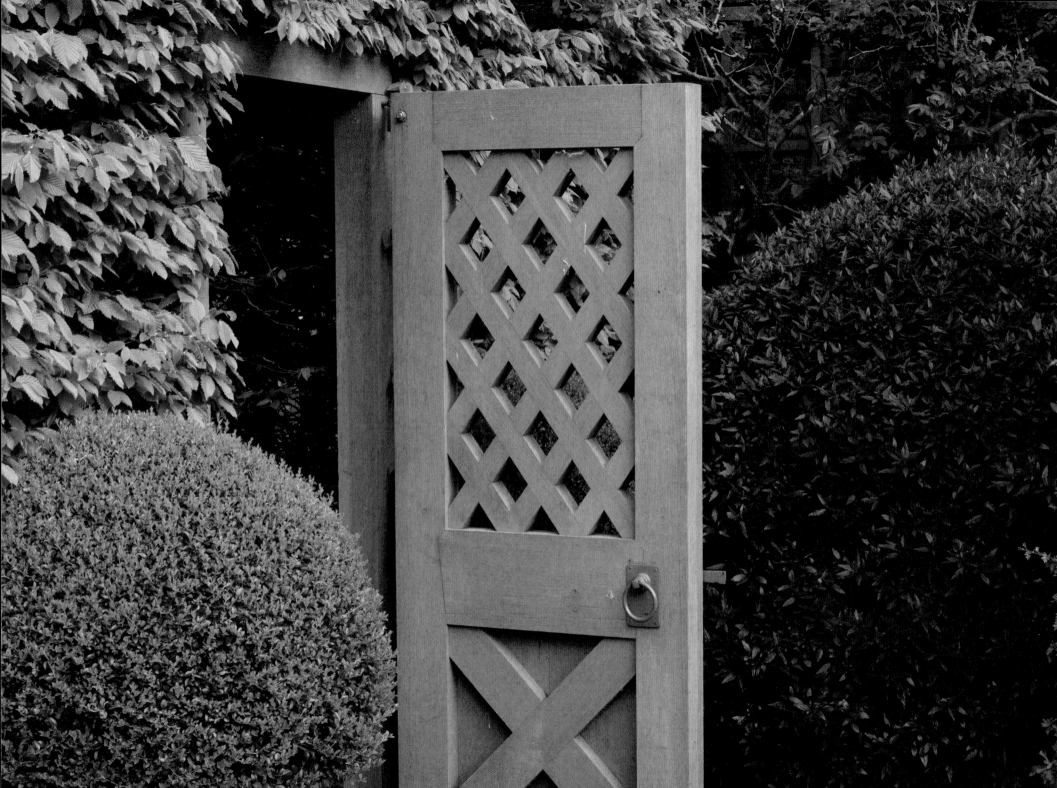

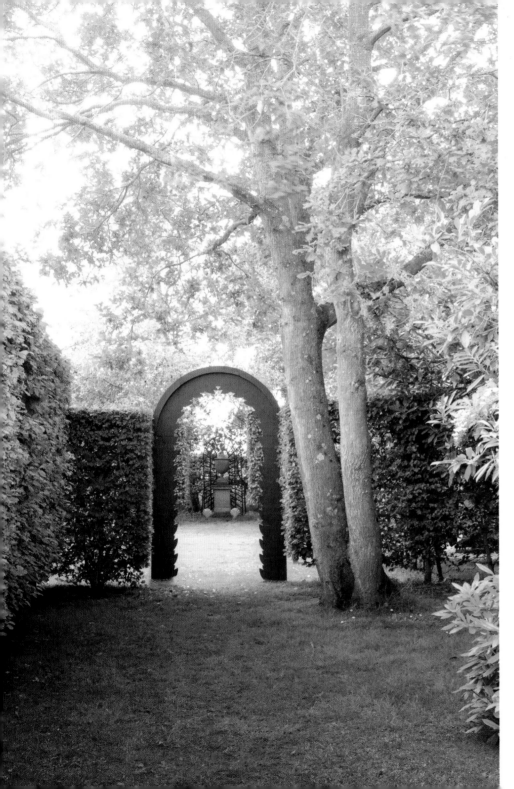

The hedge in this type of formal garden design becomes the architecture of a garden – the hedge representing, as it were, the walls of a house. By making a portal in the hedge, it becomes a more architectural space and more spatially interesting.

Far left: This is one way of linking the space on both sides of a hedge – a timber door, set into a simple frame. Treating the hedge as a wall immediately reinforces the idea of an outdoor room.

Left: Inserting a plywood arch into an opening in a hedge will give greater architectural definition than would come from an unframed gap. The arch is just a piece of green-painted shuttering ply – my favourite material to work with – cut to suggest foliage using an electric jigsaw and painted dark green to make it stand out from the green of the hedge.

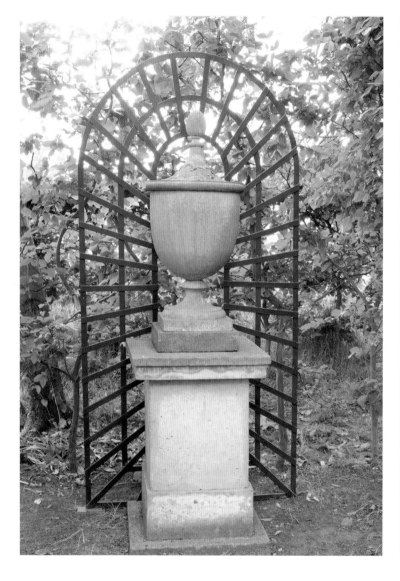

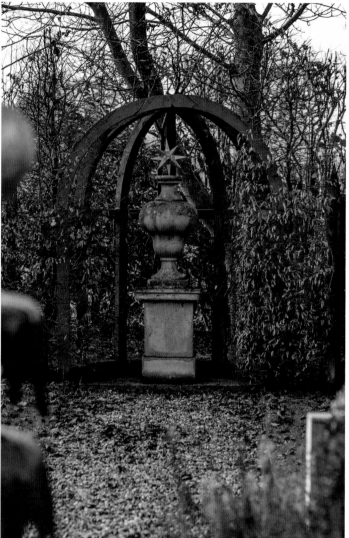

Framing a view-stopper – such as a piece of sculpture or an urn – is very much in the formal tradition. An urn is a good shape; it appears solid and comes in many styles and materials. Shown here are three different ways of framing an urn.

Far left: An off-the-peg perspective piece of trellis is easy to find in garden centres, and very effective in emphasising what is in front of it.

Left: I have used a piece of carpenters' work as a frame for a clipped hedge niche – the hedge will grow around it.

Right: A painted plywood arch; painting it a dark colour throws the lighter-coloured urn and the light garden beyond into sharp relief. The height of the frame matters – even in a small garden – so it is important not to underscale; the larger the frame – even at the end of the garden – the more impact it will have. And an overscaled structure in the foreground gives a greater sense of spaciousness and grandeur. On the other hand, an

underscaled opening (underscaled as relating to human scale) will give an interesting distortion to the scale of everything surrounding it – making everything look larger and the underscaled object appear further away than it really is.

Both the urns opposite are cast stone – which weathers well and improves with age – and there are numerous examples to be found, from the antique to the new and mass-produced; if you choose a new cast stone or terracotta urn, the aged look can be encouraged by adding yoghurt, sour milk or even beer to the surface (which, to be really effective, you dampen or soak first) and rubbing dirt into the surface encourages patina. The cut-out plywood urn, right, which is made from shuttering ply with simple applied three-dimentional detail, is a sort of pictorial trick, and works particularly well at a distance, where the simplicity of the detail has more impact than fussy detail would.

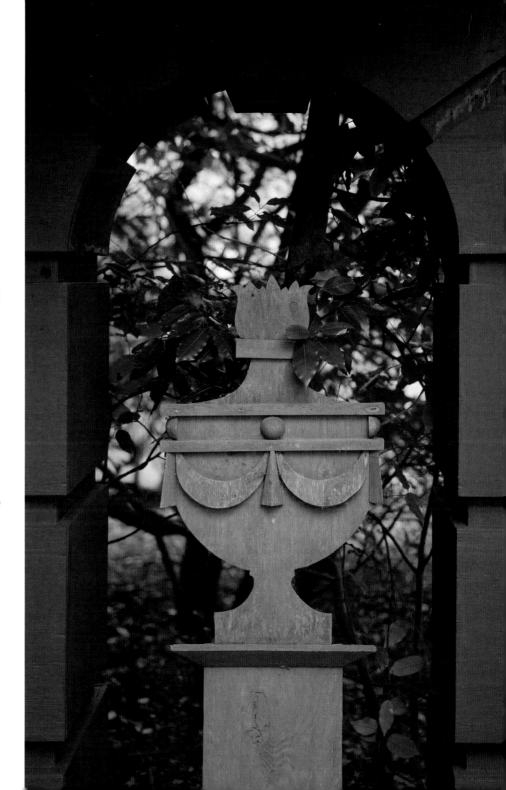

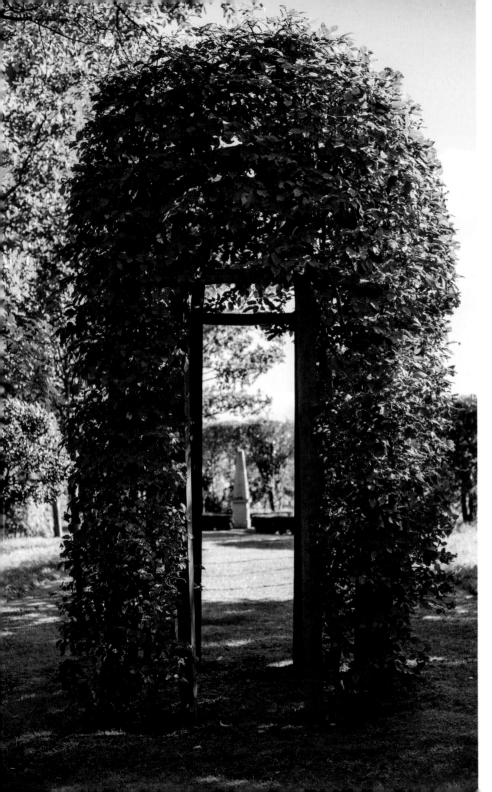

The classical temple was a recurring theme in 17th- and 18th-century gardens – sometimes an object in itself, but also designed to frame views. Here I have created the simplest of temples on which to train hornbeam using a basic carpenters' work frame – although you could make it even simpler still by just using canes, and tying them into a rounded arch shape. The frame is surrounded by a circle of *Quercus ilex* standards, and irregular domes of native privet *(Ligustrum vulgare)*. The view that the temple frames is, at one end, an obelisk, and at the other, a cottage, and the purpose is to give an approach to the cottage as well as providing a view back through an avenue of pollarded limes. All the plant material that I've used would have been around in the 17th century; today, whether you are in Britain or any other country, it's good to use a large percentage of native plant material, especially in town gardens, as they provide a better habitat for wildlife than imported, hybridised plants, and – being native – they also also thrive well.

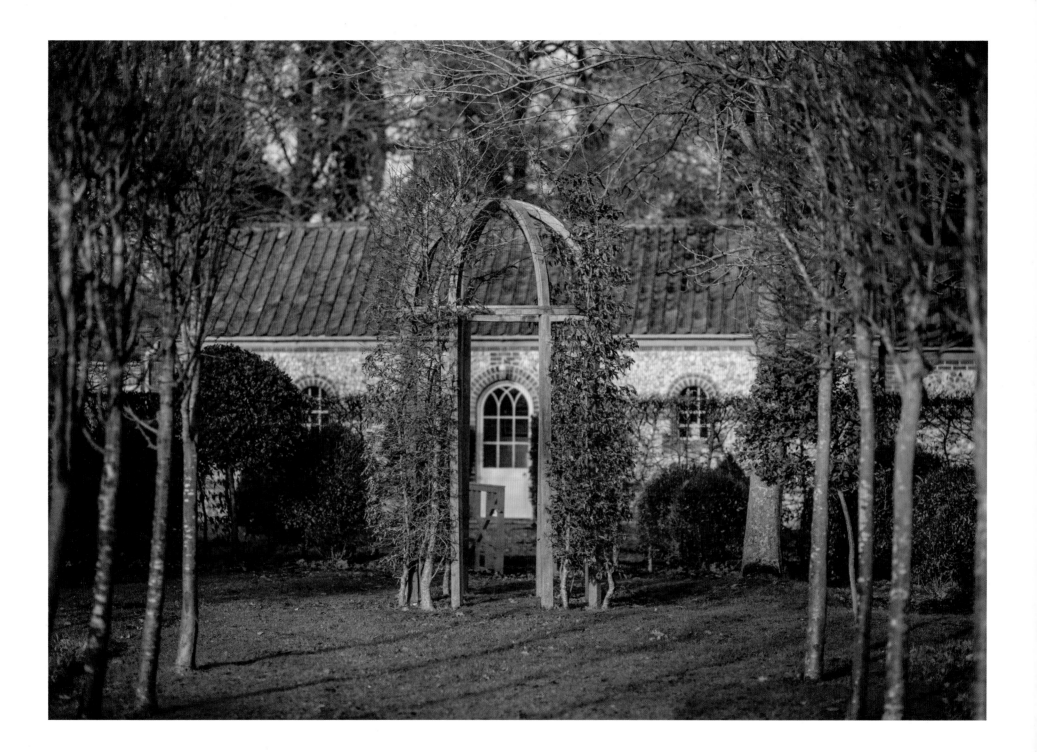

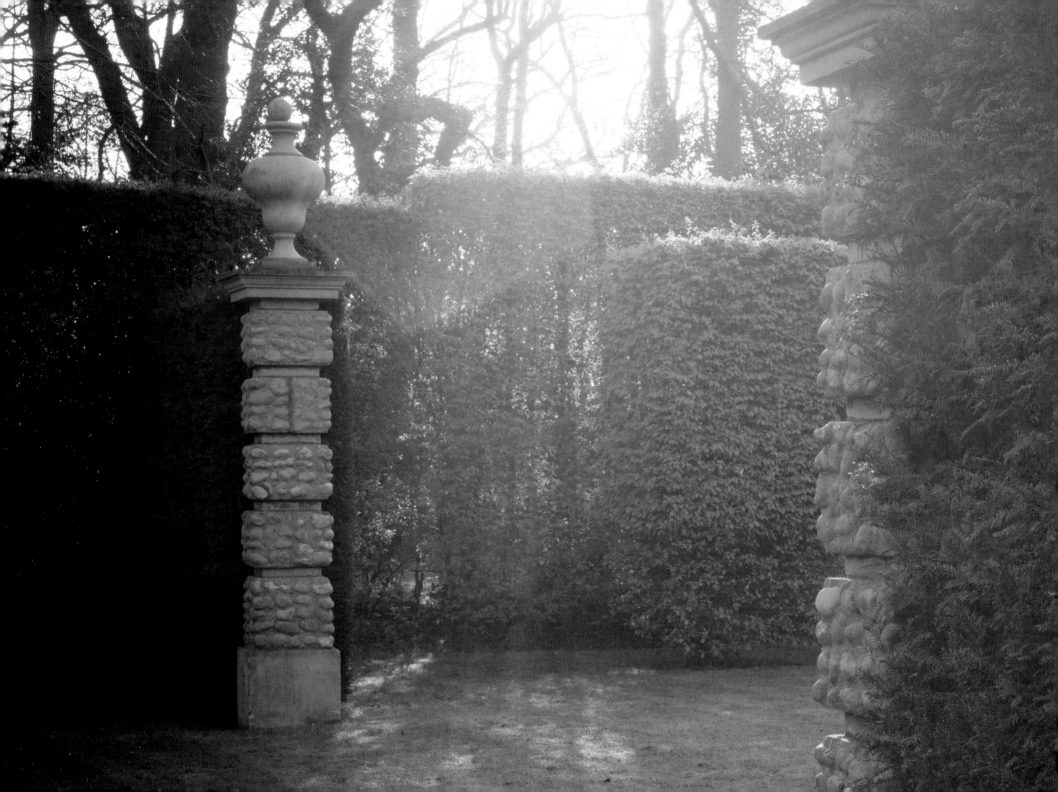

This area of the garden is my green
theatre, where I have created an
entrance with yew hedges making the
theatre wings and a proscenium marked
by flint columns with finials; I've used
flint because I like the knobbly patina
and because it is native to the region,
but you could use any material. It
might be precast flint and concrete
blocks, which are widely available (see
Directory p123); or simple stone blocks,
precast concrete or even timber posts.
Behind the yew hedges is a semi-circle
of hornbeam, which forms a good
backdrop, grows quickly and can be
kept quite thin if you prune it. Columns
of any growing material, not just
hornbeam – and which you can often
find ready-grown if you are impatient
for results – are particularly effective in
a small garden as they create and frame
the view, immediately creating two
spaces from one.

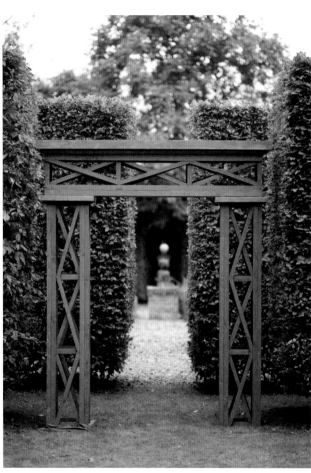

Left: I have made a timber arch which could either be used, as it is here, as something which frames a view, or – if you wanted a less severe look – it could be a pergola planted with climbing roses. It can be made from off-the-peg items – panels of trellis used as columns. I added a lintel in the same style, made out of 2 × 1in (50 × 25mm) sawn finished timber and with a timber and ply cornice.

Right: A design for a raised seating area enclosed by trellis walls, within a larger garden. An arch leads the eye to the garden beyond.

Far right: A garden building in the same style as the trellis timber arch is one of a pair facing east and west to make a pleasant morning or evening sitting spot. Inside the shelter are metal and wood slatted chairs from Ikea, and a small round metal table, available from garden centres – all painted in Farrow & Ball exterior eggshell finish 'Green Smoke'. The terracotta bust half-concealed in the hedge is a piece of architectural salvage, and is set on crude timber staging; smaller pieces could be set on a standard timber post from a garden centre.

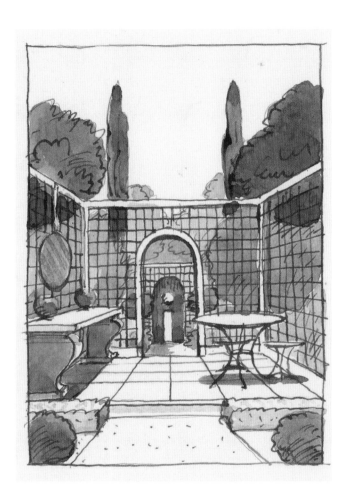

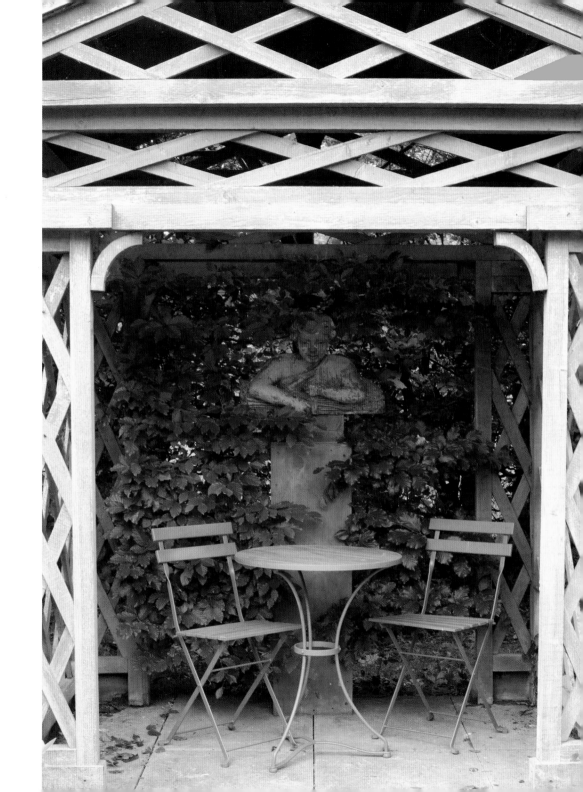

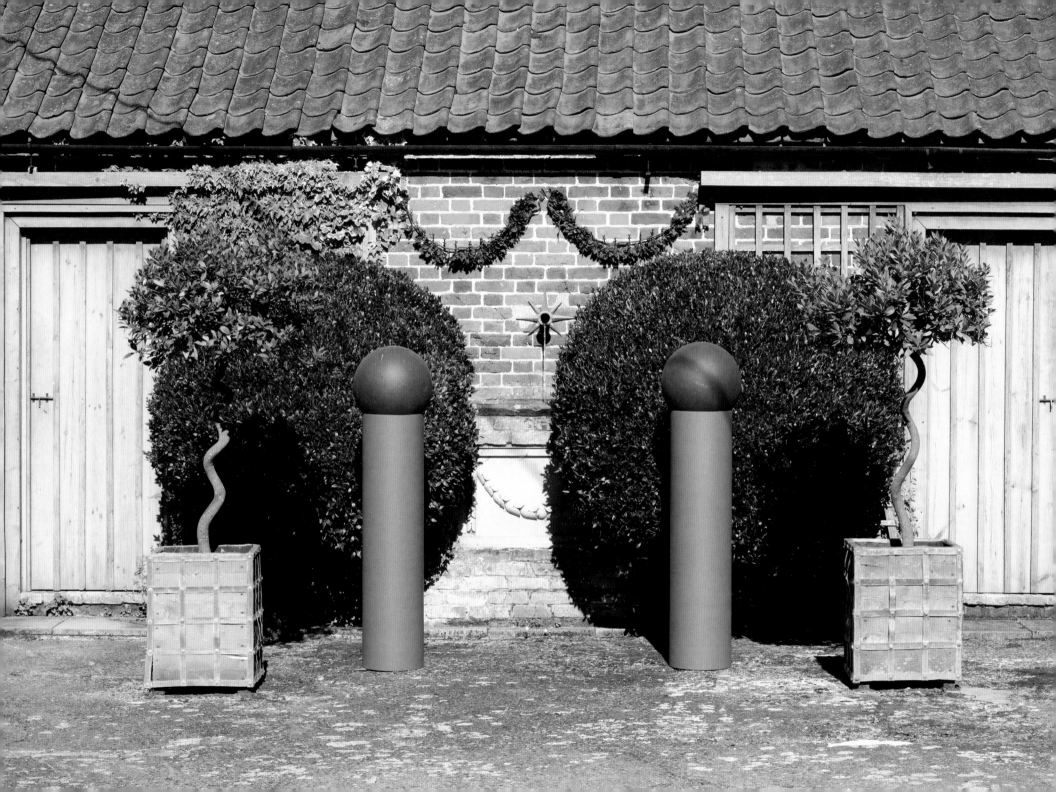

Repeating pairs of objects or plants is a good thing to do in a garden; you can't really overdo it. You can either repeat the same thing or devise a number of different shapes, textures or objects in pairs. Repeated pairs give as much interest in a garden as ten different-coloured plantings, and it works best when they are strongly three-dimensional.

Left: Illustrated here are four different pairings, which together make a strong composition. The pair of doors on the wall are real, but I sometimes attach a door onto a wall at the end of a garden to give an illusion of the garden going beyond and to create an axis or a sense of symmetry. Against the wall, two large balls of *Phillyrea*; in front of those, two spiral bays in pots that are simple horizontal 6 × 1in (152 × 25mm) boards on 2.5in (64mm) posts; the lead trellis work is applied afterwards using roofing nails as fixing. In front of the *Phillyrea*, columns and balls are plastic drainage pipes from a plumbers' suppliers topped by beach balls – the pipes painted Farrow & Ball 'Green Smoke', the balls in Dulux 'Cannon'. Fake bay festoons on the wall work well with the real plantings in front.

Right: The same balls used at ground level to define an entrance and give it importance. Whatever devices that you employ in this way, simplicity should be the watchword.

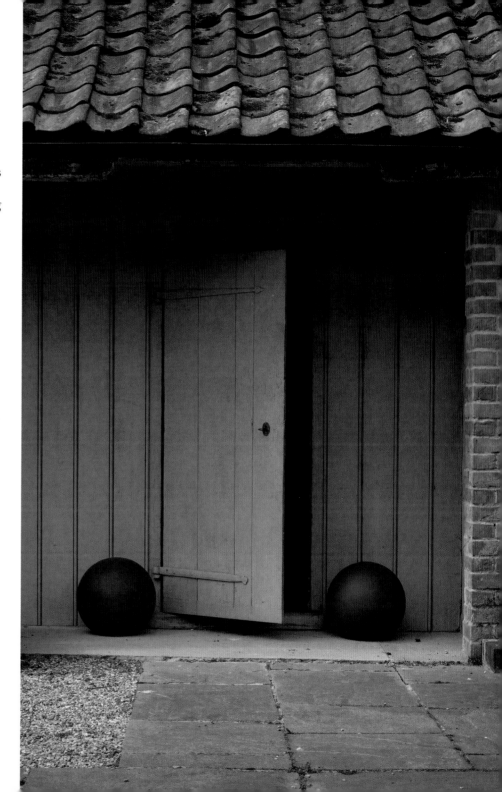

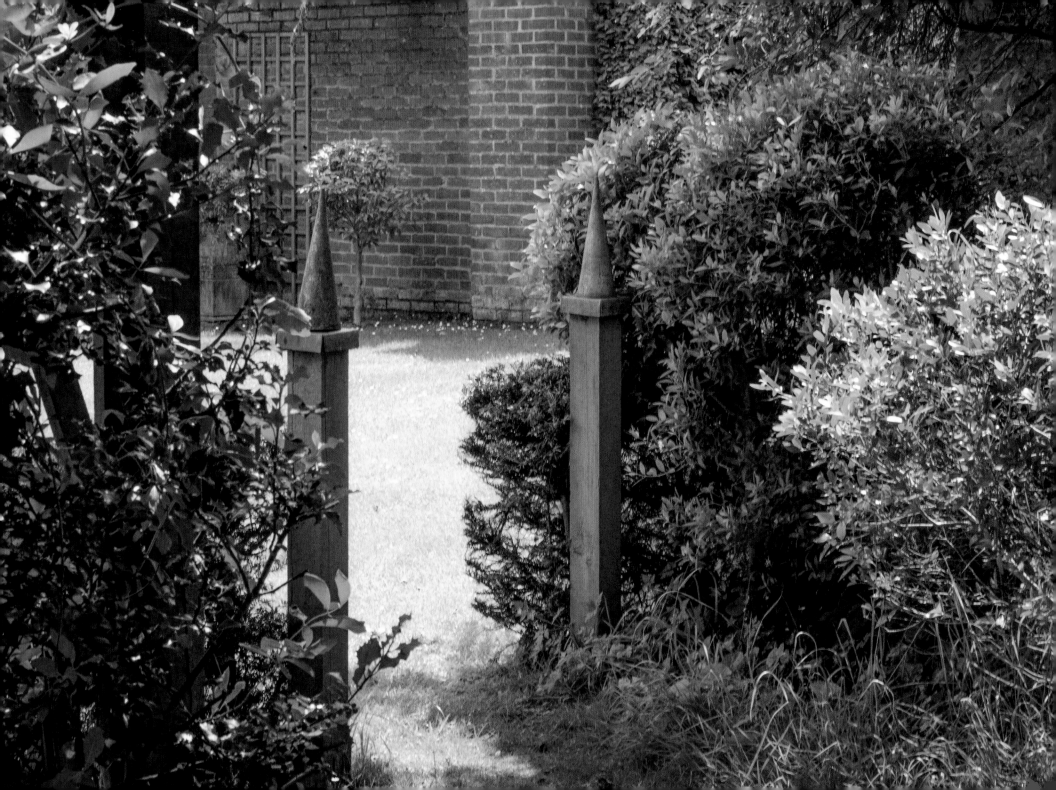

Left: A simple way of framing a view or marking a change in pace from a more manicured area to a wilder one. Formality works best if it is contrasted with informality or wilderness. These posts are simple fence posts, which can be bought cheaply at all garden centres, stained with Sadolin 'Slate Grey' and topped with finials – which could be anything from pine cones to balls or shells perhaps, painted or gilded to make them interesting.

Right: A more elaborate gate, but easy enough to make with new, everyday tools – why not three garden spades, or differing tools – from the garden centre, set in different directions and nailed into a frame. Wooden-handled tools are easier to fix and a 2 × 2in (50 × 50mm) frame provides something to screw them to; car boot sales are a very happy hunting ground. The gate is axised on the window of the house, a secondary axis emphasised by the pair of *Ligustrum* standards and box balls in pots.

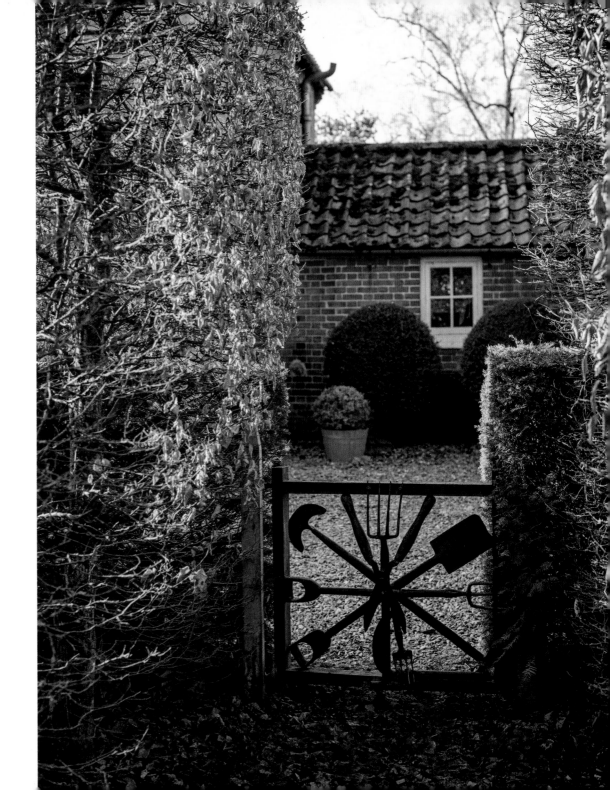

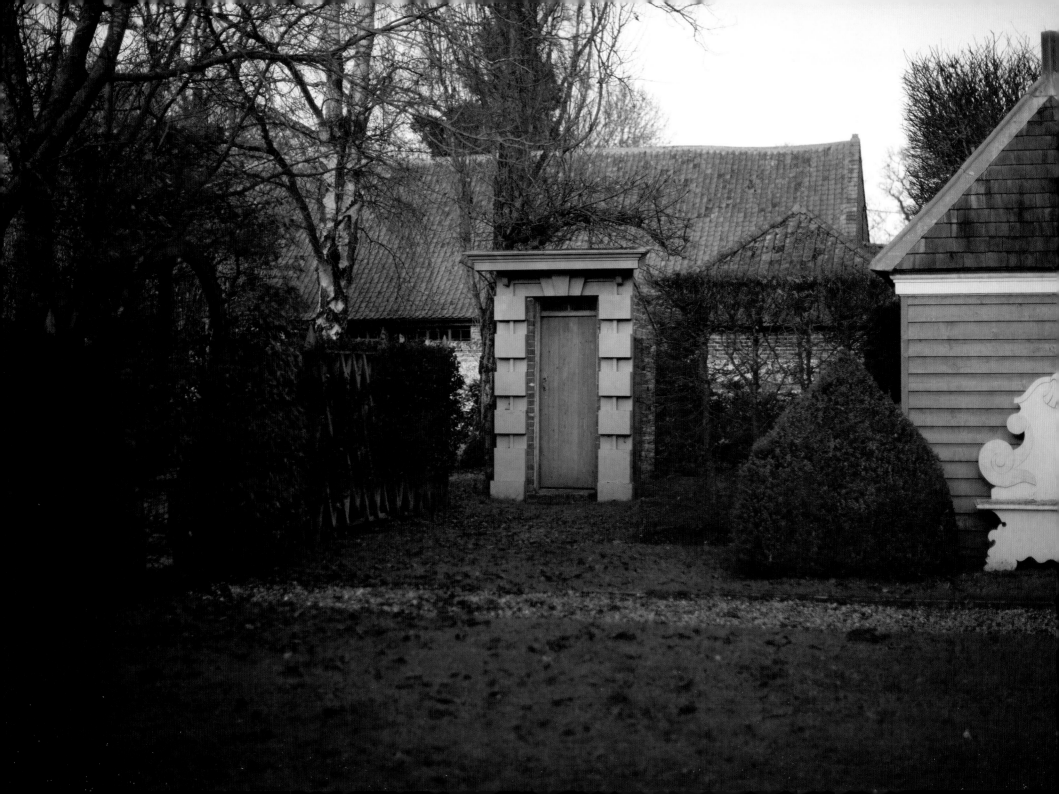

STRUCTURES

Walls and hedges are, as we have seen, an important and permanent element of the architecture of the garden, but structures, in the form of buildings and trellis, are equally important and should be seen as all part of the same scene. It's fair to say that everyone needs a shed in a garden, and as they become quite a prominent part of a small town garden, they have got to look good. Proportion is all, and almost all basic sheds lack proportion. There is no off-the-peg-shed that cannot be improved by adding decorative detail or giving it a new roofline or – at the very least – changing its colour. Today, you can buy very sophisticated ready-made wooden mouldings, from skirting to dado rails and architraves; because they are timber, they can easily be used outside, preserved and sealed and then painted as exterior wood.

Here (left) we have illustrated two sorts of building, both of which have been raised from the ordinary. On the right, a basic shed has been given an architectural makeover with a grey stain and a painted cornice, and a roof of simple shingles of cedar, which goes a very pleasing shade of grey. The overhang of the roof gives the building more substance and improves the

Two plywood sheds with galvanised steel roofs frame another with similar detail.

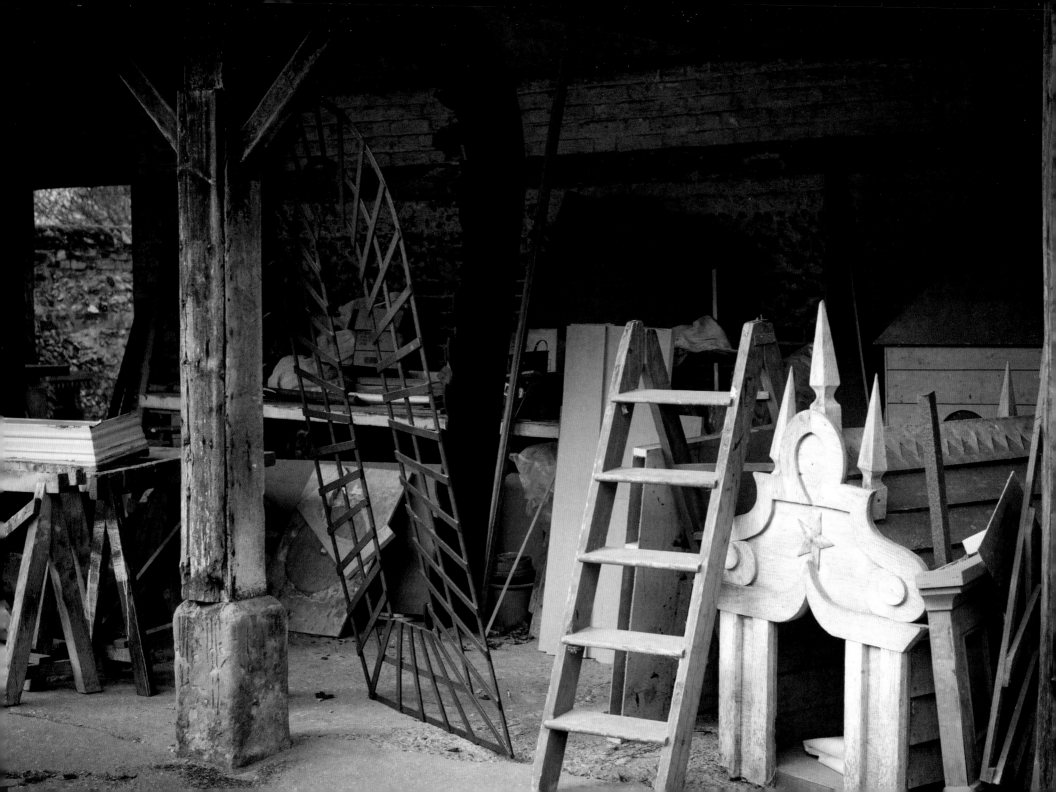

proportions of a not very nice building. The other, an outdoor lavatory, of a type found in many old gardens, has been given an architectural update with a new plywood façade

I think one needn't be frightened of looking at lots and lots of 18th-century drawings and pattern books – many of which have been reproduced (two examples are Thomas Overton, *The Temple Builders most helpful companion*, 1774, Ecco print Editions and Philip de le Bay and James Bolton compilation, *Garden Mania*, Thames & Hudson 2000) as well as looking on the internet. Such designs might, at first glance, look difficult to do but in reality they need not be; you can use plywood for the structure, and with the help of waterproof PVA glues, wood preservative and wood stain, plywood can easily be made weather proof and long lasting.

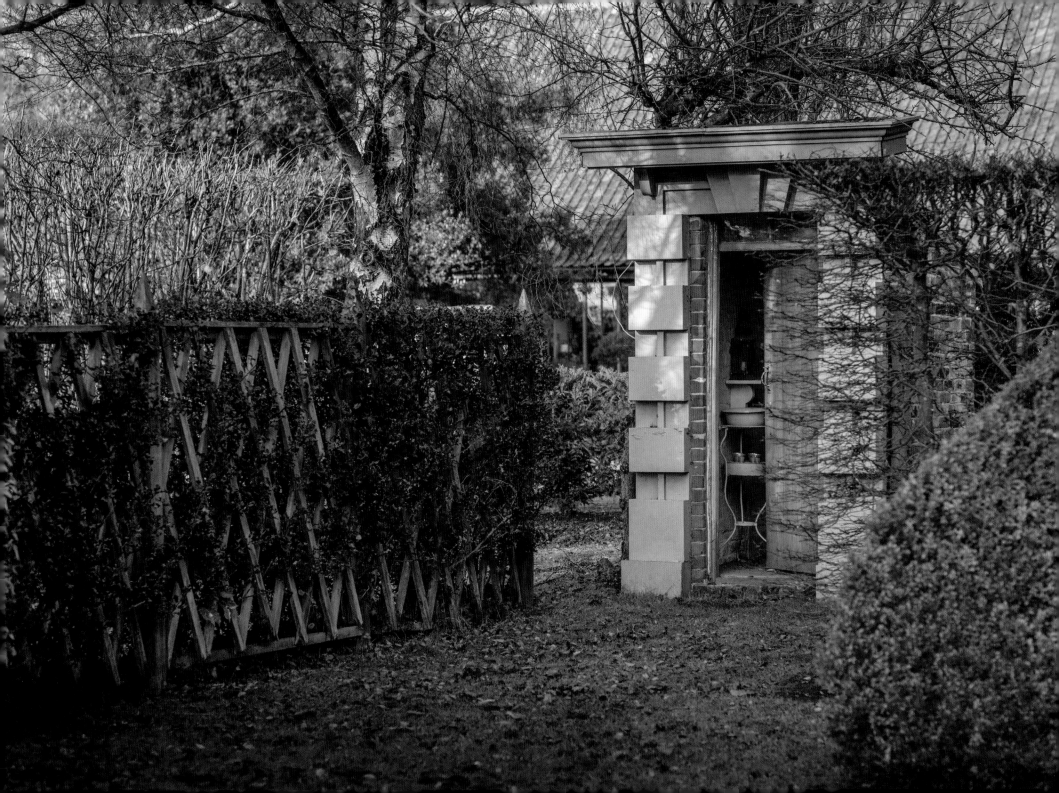

On these pages is featured a very pedestrian outside lavatory of a type that many Victorian gardens had. I have given it a new façade – a bold piece of architecture – to give presence and to make an object worthy of being a view-stopper. This idea of adding a new façade was one that much appealed to the 18th- and early 19th-century improver. Buildings were given an entirely new character with a façade in a more exciting and fashionable style, which might be the gothic, the classical or the ever-popular rustic cottage. For this I have made out of plywood a James Gibbs door case – so-called because the design, with rusticated, or rough textured, blocks, was one of the trademarks of this influential 18th-century architect. (He also produced a popular and widely read book of his building and ornament designs: *A Book of Architecture containing Designs of Buildings and Ornaments*, 1728, Dover reprint 2008.) The door case gives the building a three-dimensional presence, even if it is only in plywood. It is more a question of making the proportions more interesting than doing something complicated, and you could do it to any sort of off-the-peg shed, as we have done overleaf. Here the door has been painted a distressed grey/blue, a shade the garden designer Getrude Jekyll particularly liked as it reminded her of bleached Mediterranean shutters. The doorcase is painted Farrow and Ball 'French Grey'.

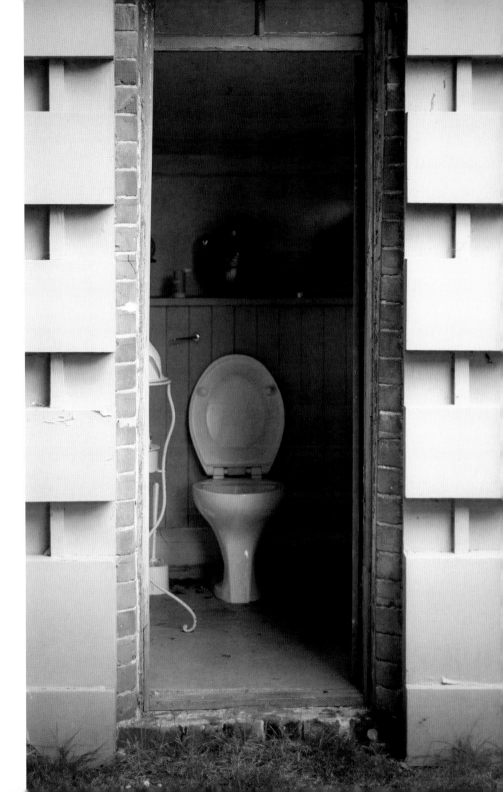

The shed here was a very basic 6ft × 4ft (1.83 × 1.2m) garden shed bought from a national garden centre and similar to the many other available basic storage buildings. A similar makeover would work on metal storage sheds where a change of colour and the addition of bolder mouldings will improve the basic structure immeasurably. The roofs of these sheds are generally out of proportion; they have no overhang, nor enough substance. To counteract that visually we have done what we did on the outside lavatory on the previous pages and attached a new façade to the front This consists of 2 ply pilasters given visual substance with 2 × 1in (50 × 25mm) timber edges and a shaped cresting to hide the roof line, the whole attached to the original/basic structure

with mirror plates or mending plates. Then, if you were inclined, you could dress up your new façade with whatever fanciful add-one you pleased. I have used a shell shape, but it could be as simple as a flat disc or a half circle. I painted in the details of the shell, but alternatively you could work with a digitally printed waterproof image, which could be mounted onto Foamex (plastic) rigid sheet. Obelisks and pointy finials complete the design, but you could vary the roofline with cones or balls or some of the other ornaments from this book.

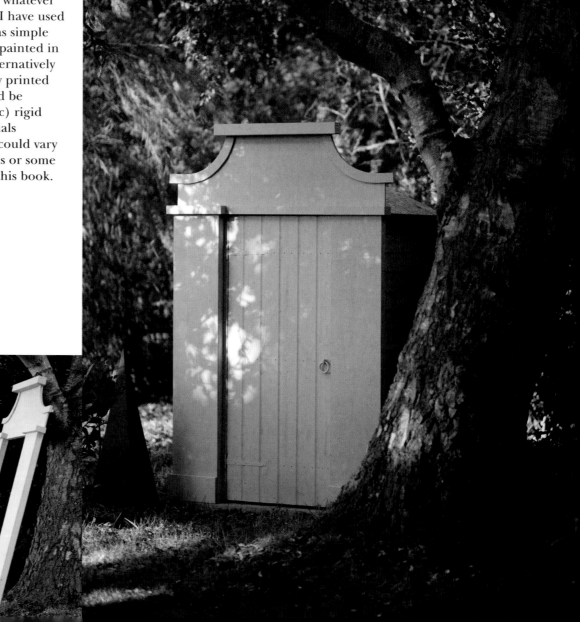

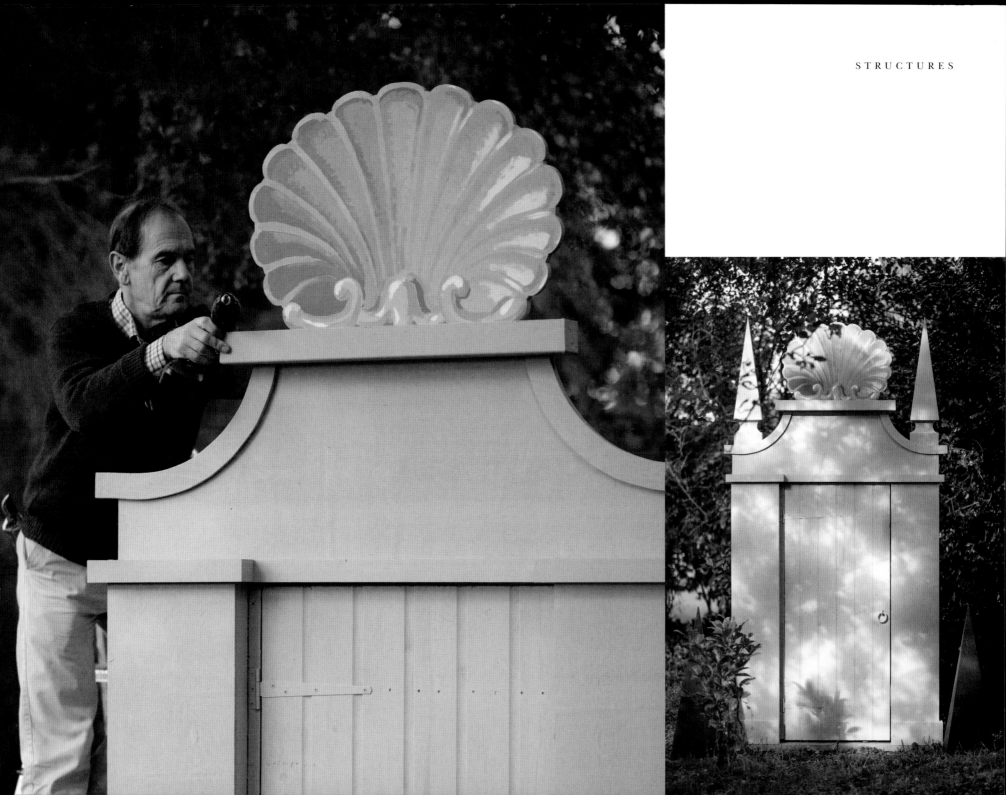

Trellis is so much more than wooden diamonds or squares. It is in fact an aesthetic in itself, and in the 17th and 18th centuries, the variety of pattern and design was incredibly varied and used in many different guises – as vertical pilasters, for instance, with closely spaced verticals and lower horizontals, or as Chinese fret. You can use trellis to create not only divisions between different parts of the garden, but also to make different scales and effects; don't restrict yourself to one style or pattern – they can all work together if you paint the trellis the same colour throughout the garden. You might, for example, contrast large, square, open trellis with much closer-spaced laths to create pilasters or a contrasting scale of grid that paces a long run of trellis. When considering what trellis to use, you could buy it ready-made or make it yourself from stock material.

Left: An ornamental plant-supporting obelisk is made from stock items, nailed together. One timber section that I find very useful is 1.5 × 0.75in (38 × 19mm) pressure-treated tiling batten, which is available as a stock item from builders' merchants. This is a good size for reasonably substantial trellis and the sawn finish makes it easy to stain.

Right: A pair of trellis obelisks frames a door into the house.

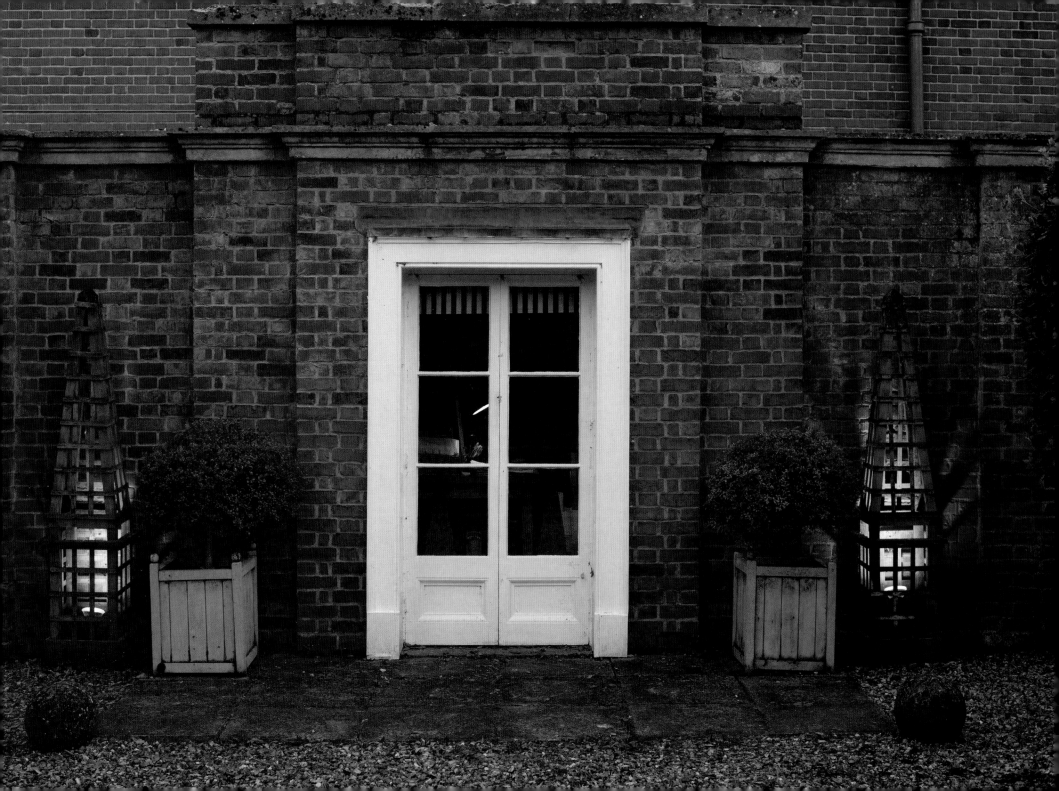

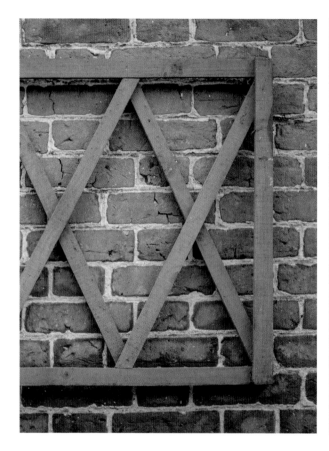 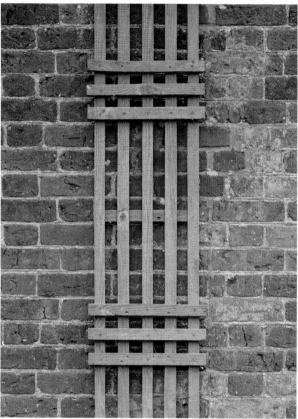 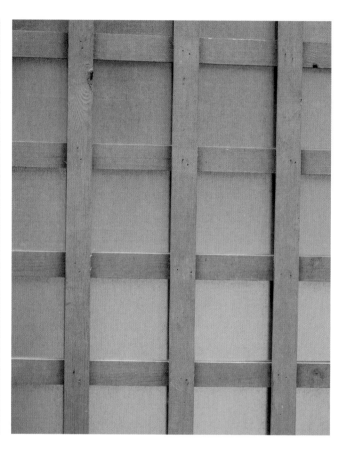

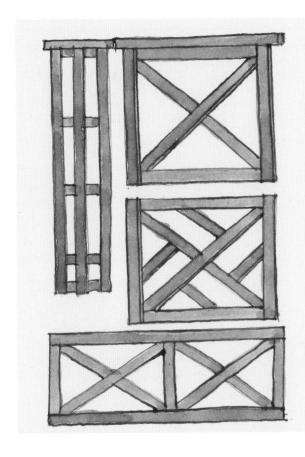

These are some examples of the wide range of trellis patterns that you can put together yourself.

Far left: Large scale diamond trellis, based on the type of trellis seen in Dutch engravings of 16th-century gardens, which I use throughout the garden as low fencing and to support plants or, as shown right, to provide the illusion of a mature hedge while it is still growing on from small plants – in this case holly (*Ilex × meserveae* 'Blue Prince').

Centre left: A trellis pilaster, which works well against a wall, both helping to break up a wall into compartments and also to act as a support for clematis, jasmine, rose or other climbing plants.

Left: Simple trellis, which has been backed with standard galvanised steel sheet; this is particularly effective as a boundary screen at the end of a garden or against a wall in a small garden, as it reflects light back into the space and dissolves the boundary. It is simple to screw a sheet of galvanised steel into the outer frame of the trellis from the back.

Below: Some of the many patterns of trellis to be found.

Right: Diamond trellis, topped with a finial and used as fencing and to support some planting and to give the effect of the finished height of the hedge.

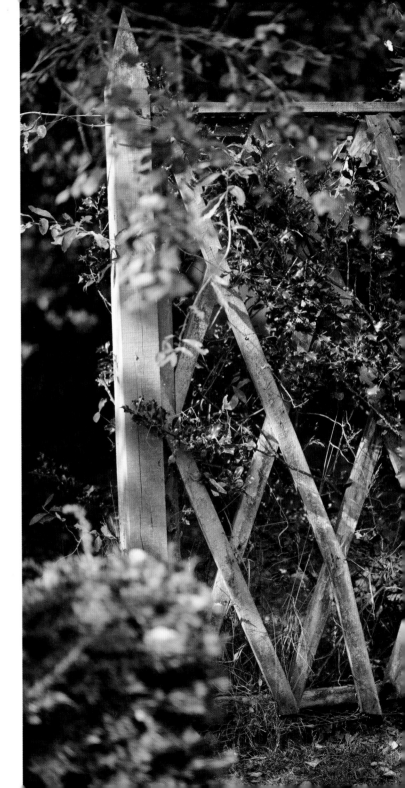

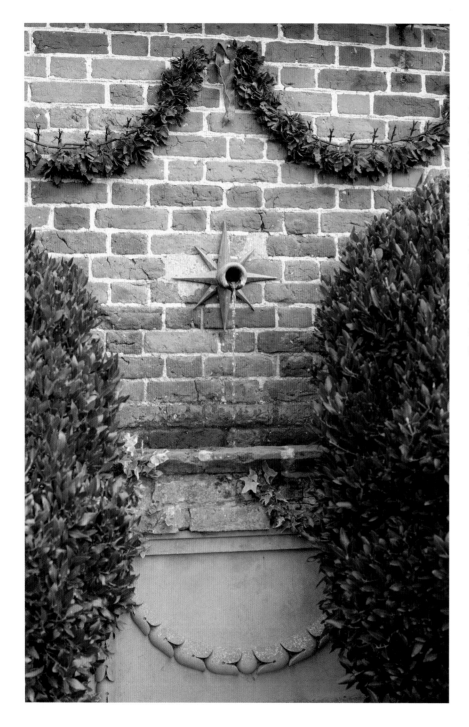

Once a blank wall, we have turned this into a view-stopper by decorating and embellishing it. The brick itself is Norfolk red brick, which is naturally an attractive colour, but any brick – even if it is unattractive in tone – can be improved by just whitewashing it, to make it look slightly distressed. A thin coat of lime wash or slightly tinted lime wash (a large range of earth colours is available) will improve the nastiest of materials – not just brick , but even concrete blocks or unpainted render become instantly better looking; and as a bonus, the more weather-beaten it gets, the better it looks.

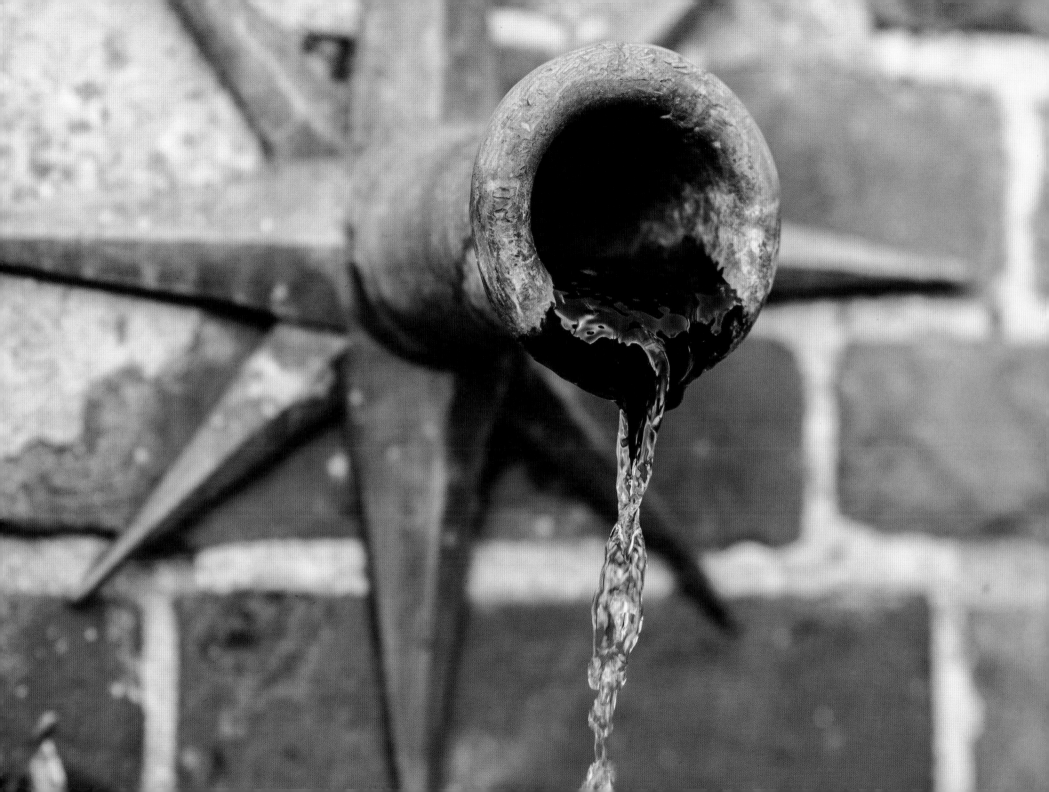

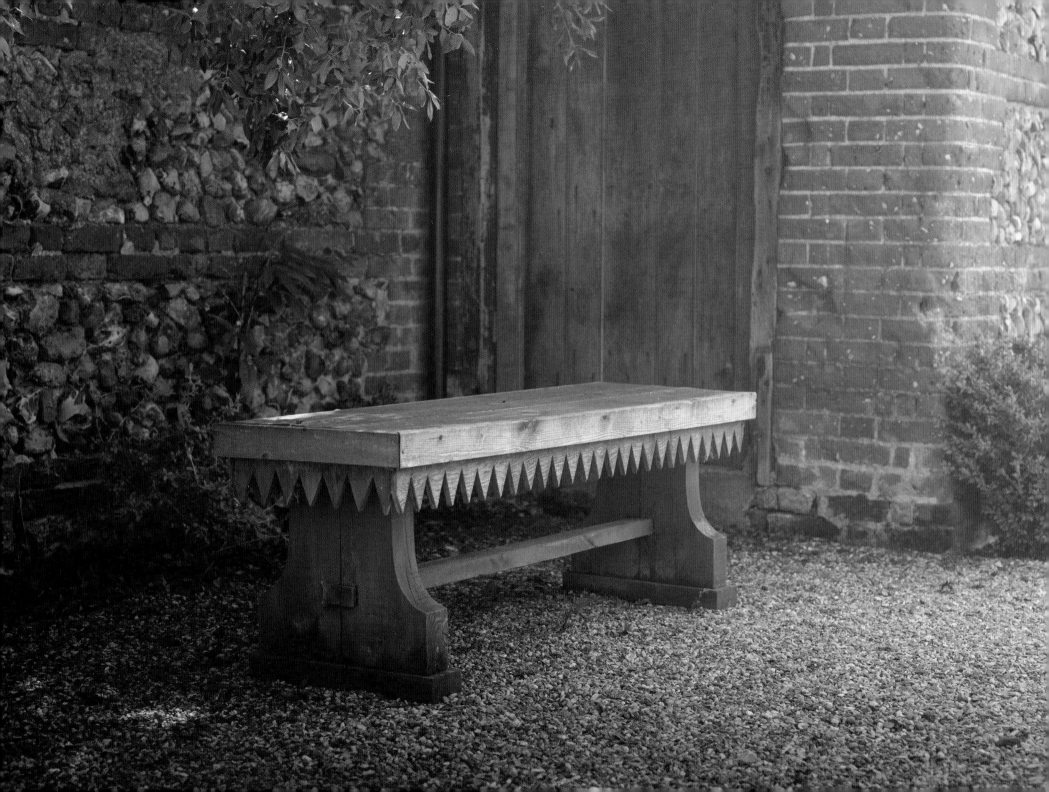

FURNITURE

I think that in a garden you need several types of furniture, ranging from very low-key basic pieces, simple benches, as left, chairs and tables, up to quite ornate pieces that act as view-stoppers or focal points. Some pieces should be lightweight and portable so that they can be moved around at different times of day and for different occasions – folding metal chairs, for example, are very useful, while other, heavier pieces should be in fixed places. A device that works well is to have several pieces of the same design – not just the obvious, such as small chairs, but larger benches and more substantial ornamental pieces. There is an interesting symmetry and coherence in repeating a design. They don't have to be stylistically homogenous – indeed it can be more interesting if they are not – but the garden will work better if they are homogenous in some other way – particularly through colour. In this garden all the furniture is painted – not in a single colour, but in a family of colours that gives unity to what are sometimes not very unified styles. Paints have improved immeasurably over the last few years – they can be

tougher and better than ever. I prefer to use oil eggshell or oil undercoat, which are longer lasting and have a better finish than water-based exterior eggshell or satin finishes. There are also very durable wood stains, but these have to be used on new or bare wood.

Again, as with so many elements of garden design, looking at examples of historic garden furniture can inspire – many 17th- and 18th-century designs are not necessarily that complicated, and even if you do not want to re-create them in their entirety just looking at these early examples of outdoor furniture – two patterns which I have sketched below – can provide inspiration and lead to new ideas. They are fretted-out ply attached to the basic bench on page 69.

This sketch shows how you could add a baroque-shaped fretted-out back to the simple benches made of landscaping timber shown on page 69.

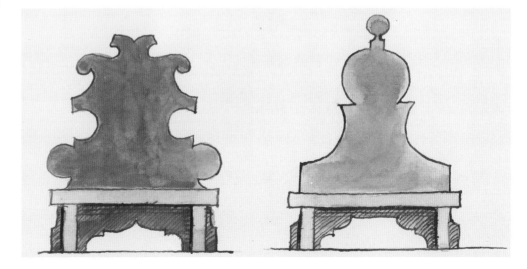

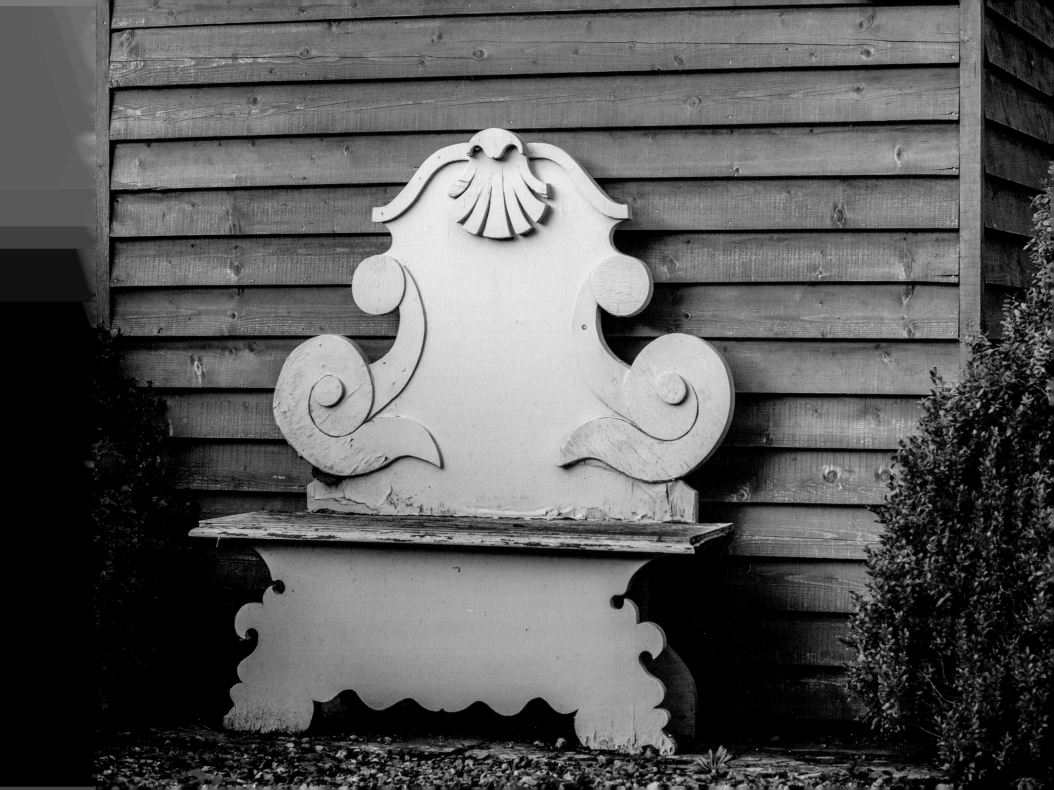

Here we see two styles of formal chairs.

Left: A shape that is half way between a chair and a bench – designed to seat two – looks quite complicated and baroque, and is based on Italian hall seats; a basic bench with a plywood shaped back screwed to it would be an way easy to make such a baroque-backed bench – see sketch page 63. A design like this can be very useful because it has such a strong outline that will read well against a hedge or a building – a plain background, which will show off the profile of the design.

Right: Another formal chair, based on an 18th-century French design, and painted – appropriately – Farrow & Ball 'French Grey'.

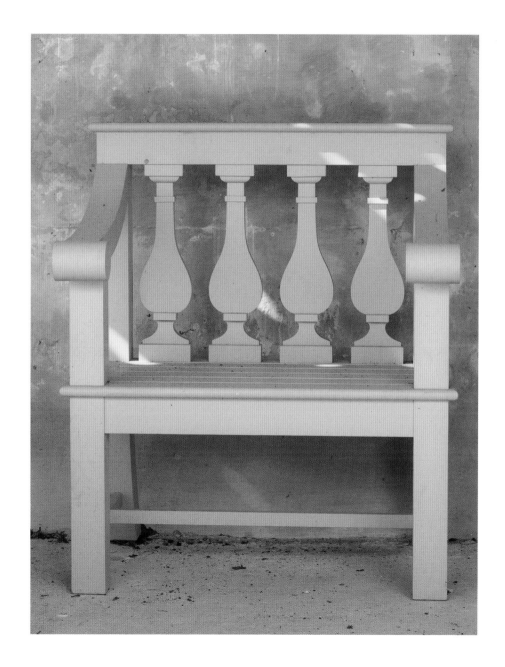

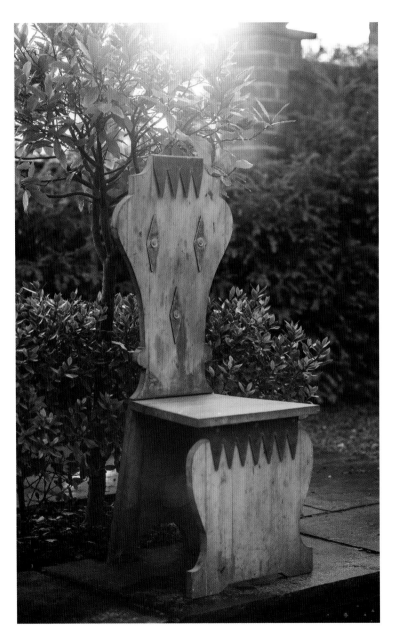

The sgabello chair, of which this is a version, has a long history dating from the 16th century. Italian in origin, where this type of backed stool was designed to stand in the hall, the style was imported to England in the 18th century along with the re-invention of Palladianism, and was soon to be found in any house that had pretensions to a hall.

This version, and my sketch right, illustrate some of the elements of the chair, including broad wood planks, bought from a DIY store, where they are sold for shelving. It has been painted in an oil-based undercoat, because oil-based undercoat left outside, without any top coat, develops a slightly friable, powdery surface. I have added very simple lead cut-outs – some gilded, and some left in their natural state – nailed directly onto the wood.

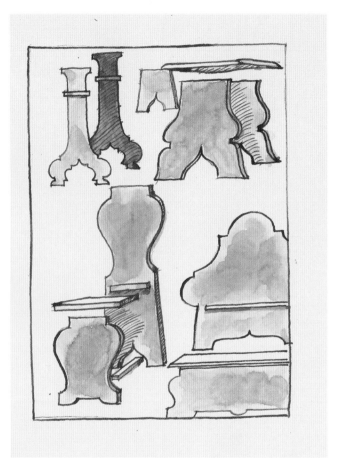

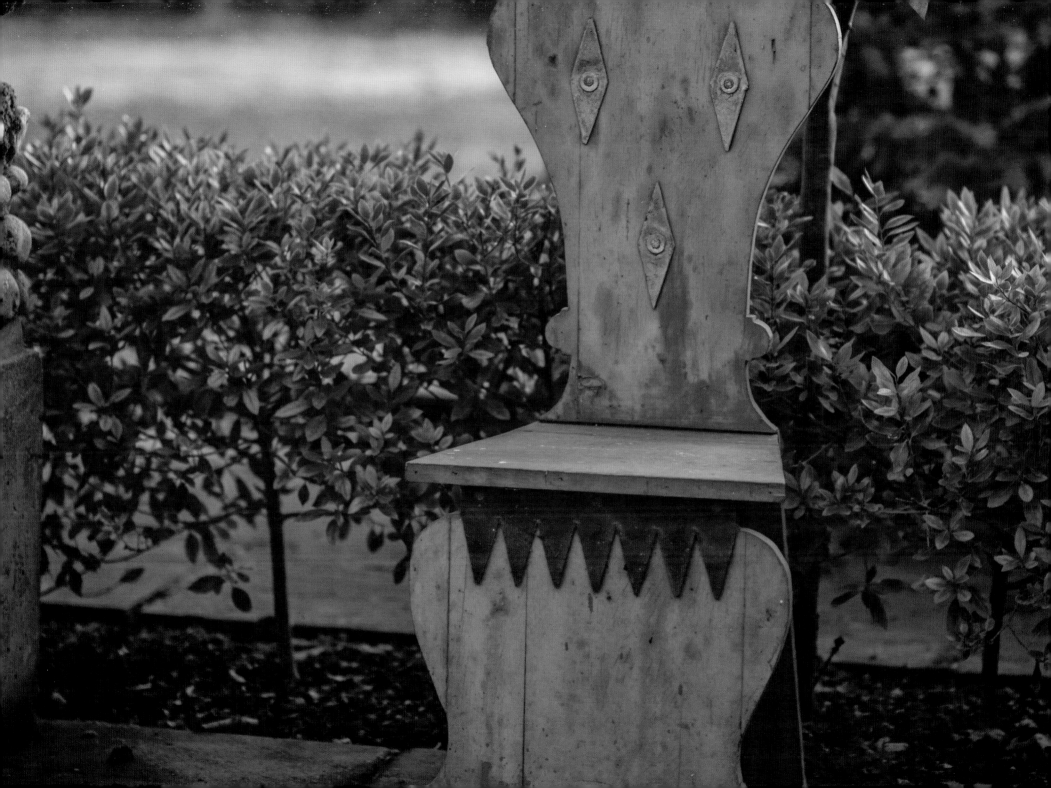

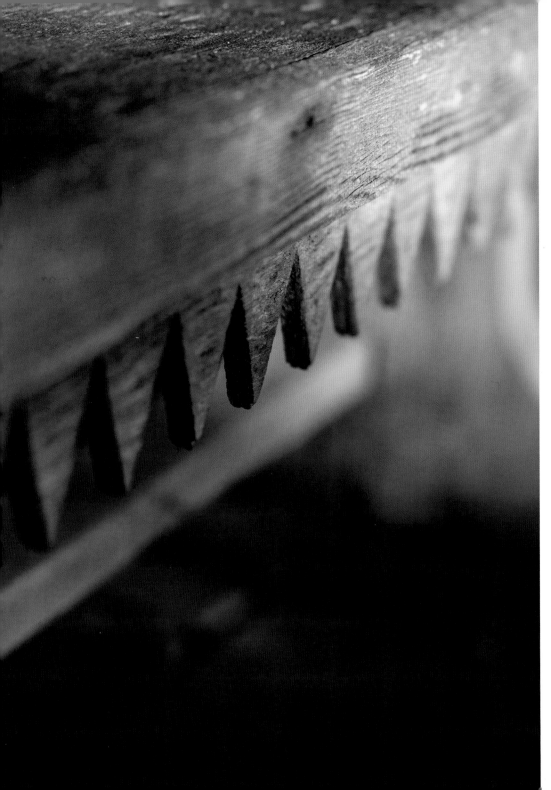

Low-key seating is as important in a garden, particularly when used as a repeat element where you want furniture which is discreet and not too attention grabbing. Used in this way, seating can be used to pace and divide up a design.

Left: A detail of the edging on the bench beneath the wall; based on the console-type benches found in 17th-and 18th-century gardens, the toothed detail is simply a cut-out frieze made from ply cut with a jigsaw from a paper zig-zag pattern.

Right: The table and benches are equally simple. The seats are made from 8 × 4in (200 × 100mm) landscaping timber from a builders' merchants which can be bought in 8ft (2.4m) lengths and dowelled or screwed together. The table is made from a pair of basic flat-pack trestles, topped with a sheet of 0.5in (12mm) shuttering plywood which has, for rigidity, been backed by 2 × 2in (50 × 50mm) timber. The table and benches are stained in Sadolin 'Slate Grey', the seats in the background are stained with Sadolin 'Smokey Blue'.

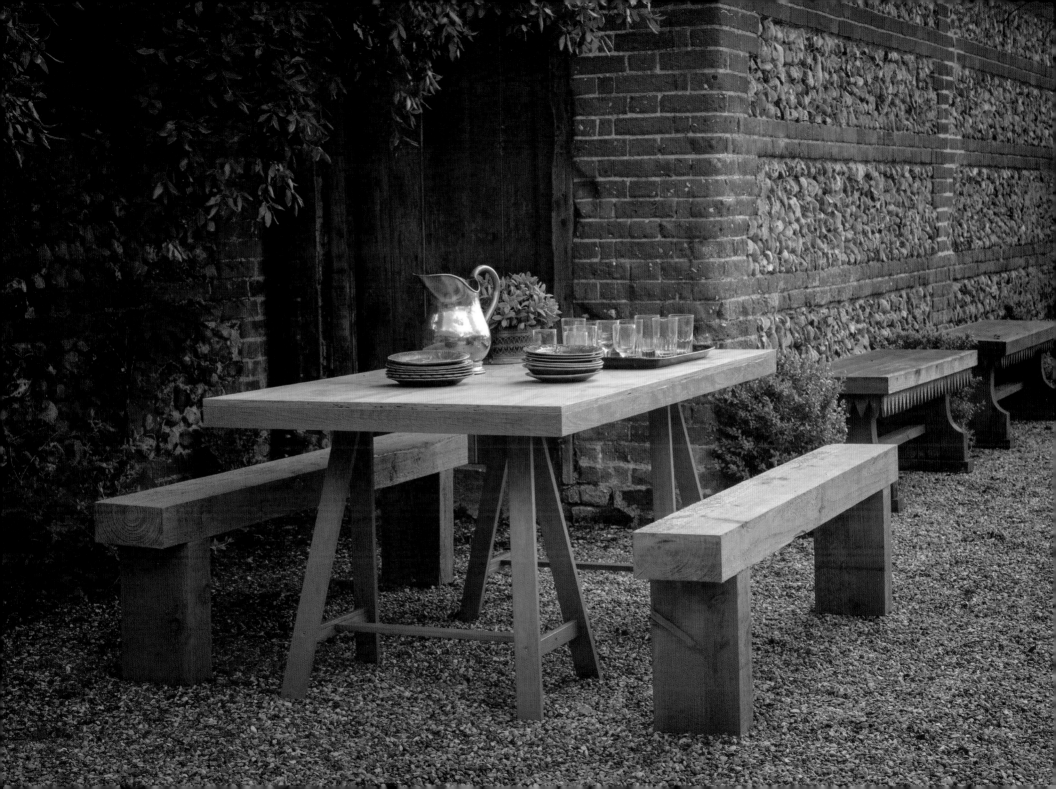

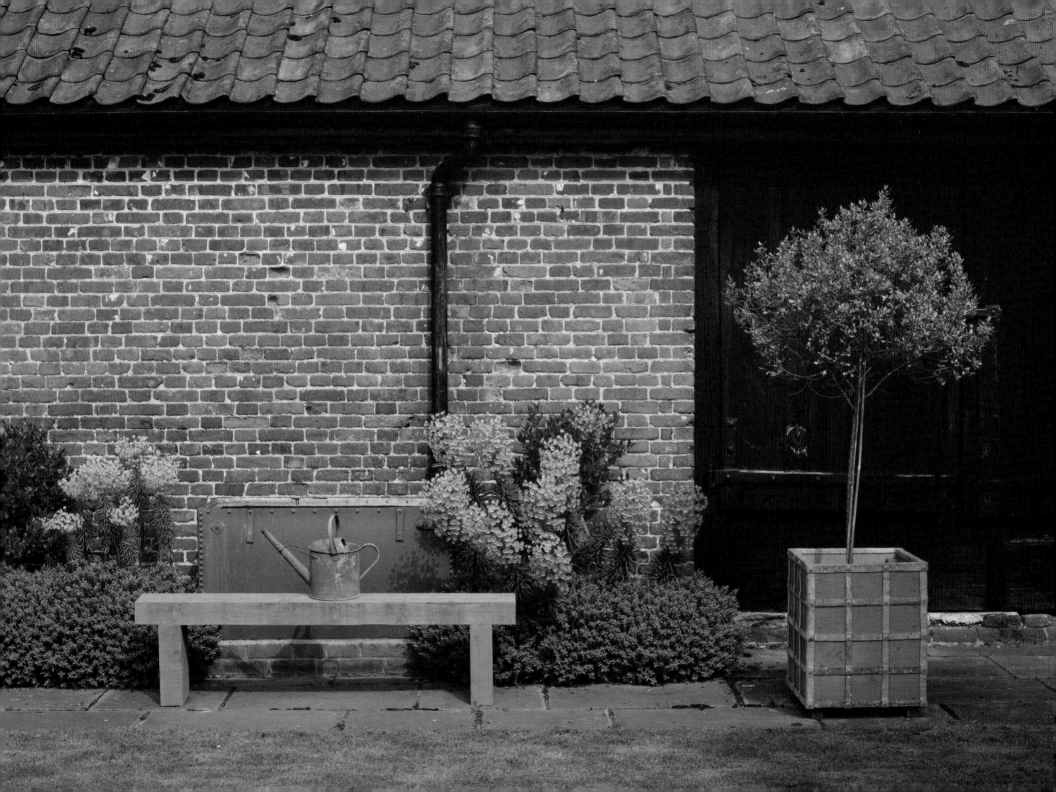

Left: Another bench made from
8 × 4in (200 × 100mm) landscaping
timber and stained, in front of an
old, galvanised tank painted in oil-
based undercoat in Dulux 'Cannon'.
Galvanised steel looks good painted in
grey-greens or grey undercoat. I have
used the same palette with the planting,
which includes *Euphorbia wulfenii*, *Hebe*
'Pewter Dome' and *Rhamnus alaternus*
'Argenteovariegata'.

Right: Two of the most common designs
of wooden chair used inside and out
were the Windsor chair and the classic
hoop-backed chair. The wooden chairs
here, which echo these classic designs,
and are painted dark green, have been
copied from an 18th-century original
from Uppark, West Sussex. They frame
the formal chair seen on page 65;
the contrast of the two shapes – one
imposing and one simple – could
be used well in a garden setting; the
Windsor chairs are more suited to a
rustic informal setting, while the more
architectural baluster chair makes a
statement in a formal arrangement.

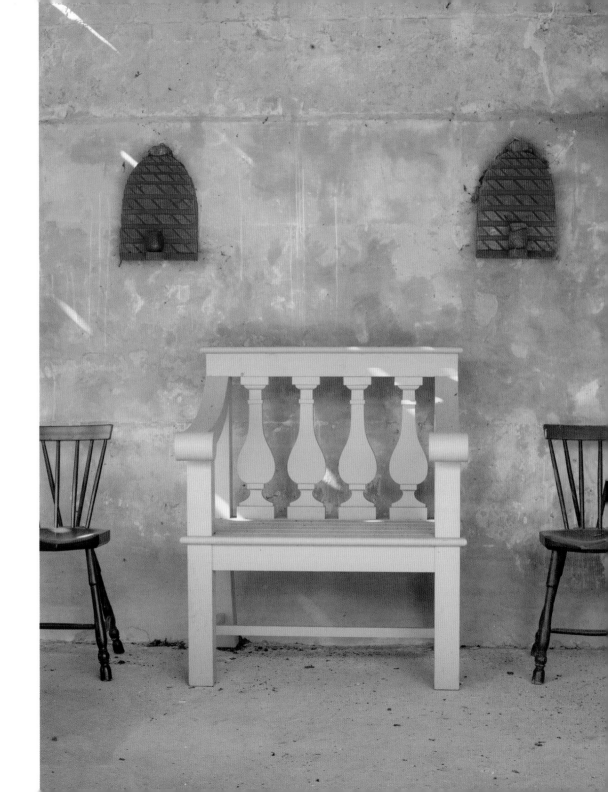

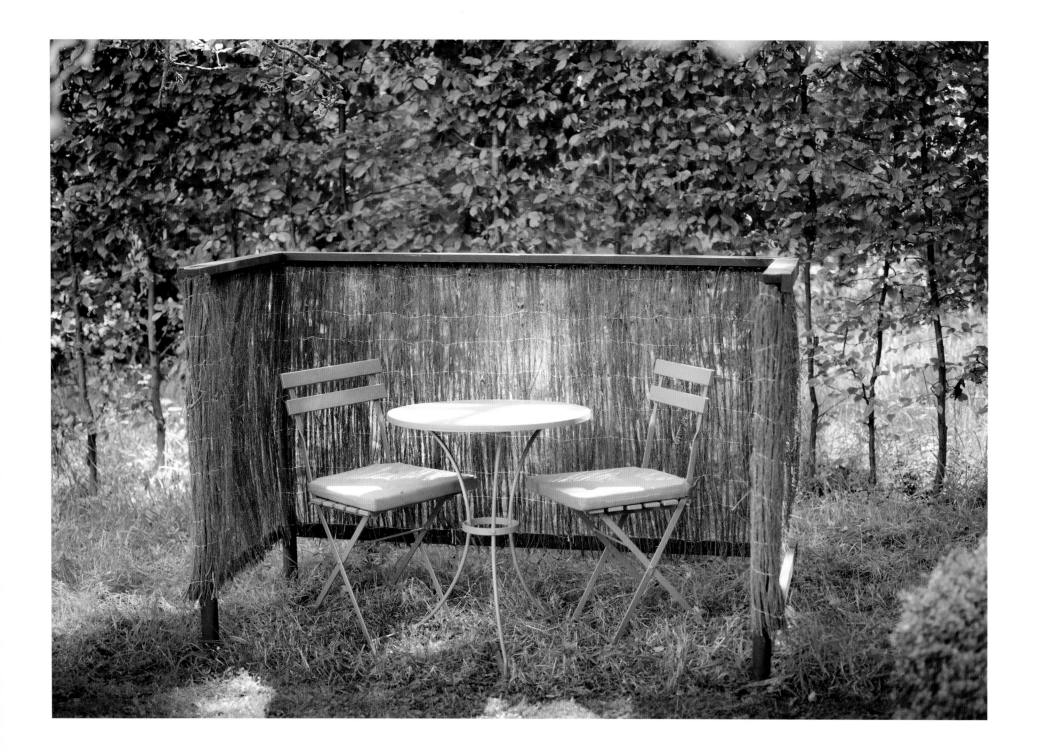

There are many ways to create a simple sitting area for a group of furniture in a small garden, giving a sense of containment and separation from other parts of the garden.

Left: The simplest of designs that works in every garden: in design terms chairs and tables are fairly lightweight and so work well anywhere you don't want too much visual business going on. As they are portable they are easy to rearrange where and when you need them, as here surrounded by trellis and foliage. Chairs and tables like these are widely available and inexpensive, and will be improved by painting them to match the overall tone of the garden; here, they are painted in a soft grey-green – Farrow & Ball 'Green Smoke' – which looks well against the darker foliage.

Right: To make a self-contained seating area I have used woven-heather wind screening from a garden centre, but the options are many. It could be done with trellis, or screening made from bamboo, hazel or willow – all now available from garden centres – and you could do it in a short time, a bit like putting up beach wind-screening. This particular area is small, but it could of course be larger – twice as tall and twice as wide. Here, four round tree support posts have been knocked into the ground with a mallet and are joined by painted 2 × 1in (50 × 25mm) battens screwed to the posts. The heather screening is stapled to the posts and horizontals.

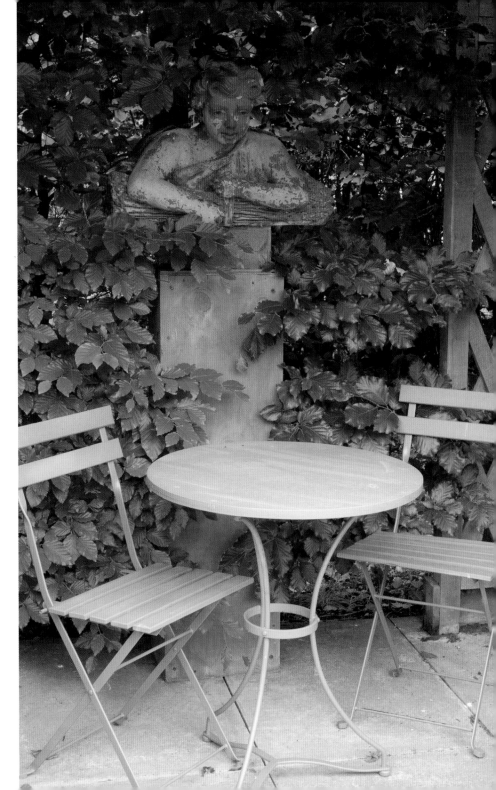

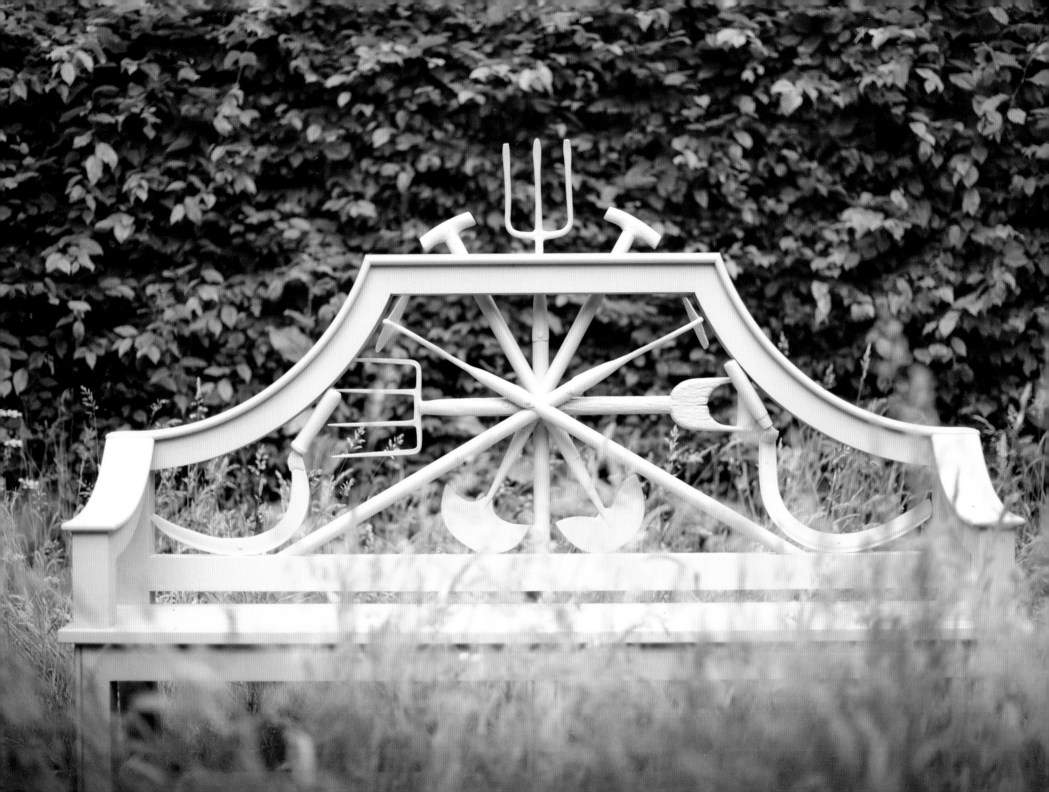

Although this is a design that I made for a commission, it would be quite possible, and not too difficult, to customise a simple off-the-peg seat with something like a repeat pattern of rakes or forks.

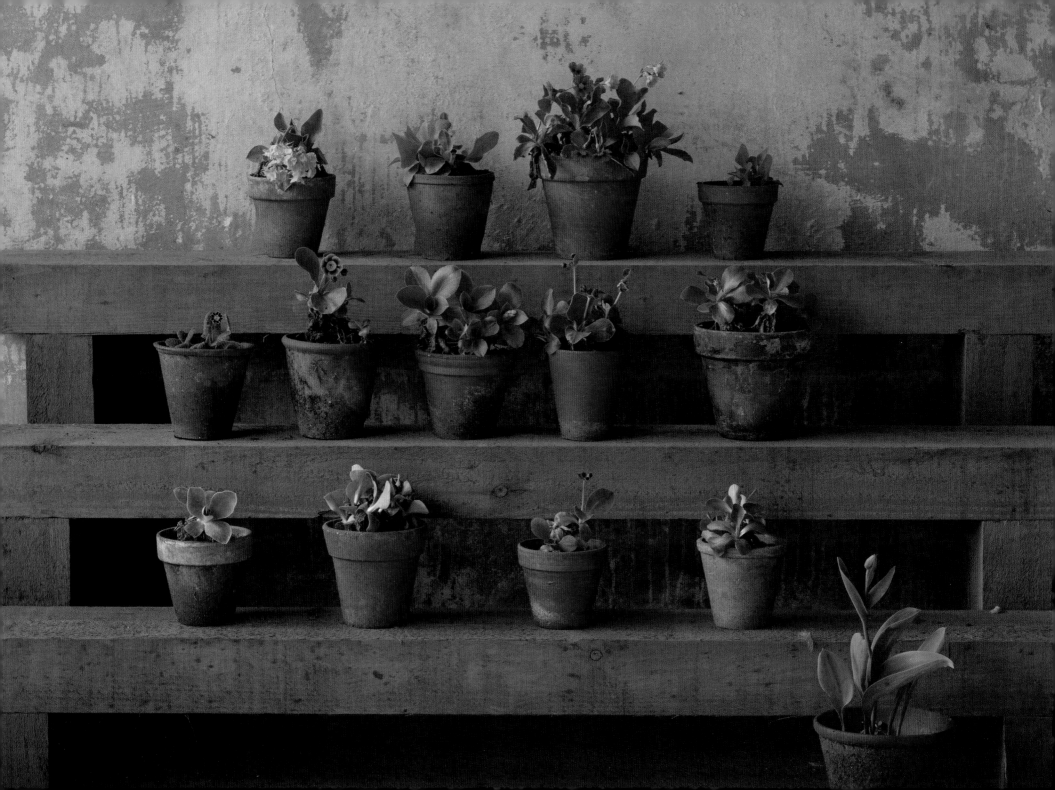

CONTAINERS

Plant containers are about holding plants, of course, but they are also about showing off each plant, to present it at its most attractive, which is why it is useful to try and think in a slightly different way about them. They also make a statement themselves in a design. The garden centre, for example, is an excellent source of ideas – not only because it is easy, with a little imagination, to improve the basic pots that are on sale there, but also because much of what else is on offer can be used in a different and creative way. Never dismiss anything at first glance – lateral thinking is the answer wherever you look. Pipes and wooden bed-edging, metal air-conditioning ducts – even pressed-paper hanging basket containers – can all have a place. As always in the garden, scale and arrangement are important – consider arranging pots and containers on staging and at different levels; using pots of differing sizes and varying shapes, in effect creating a composition. Think about plant cases – like the Versailles case, or cache-pots, which are basically decorative outer sleeves for everyday containers and off-the-peg machine-made pots. All of these can be imaginatively used.

A wirework hanging basket on a painted plastic pipe – smaller diameter of pipe forms the base to the basket.

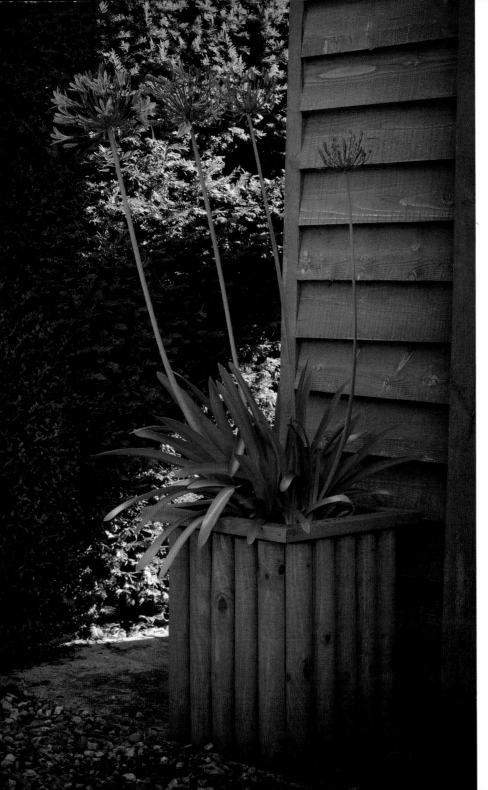

Left and below: An expensive looking container, but easy to make a simple cache-pot, made from half-round bed edging, found at B&Q and other DIY outlets. The edging comes ready-wired so it only needs to be put together around a square frame of 2 × 1in (50 × 25m) battens at the top and two 2 × 1in (50 × 25m) battens opposite each other at the base. It has been stained with Sadolin, 'Slate Grey'. Used with a base inside, it could be a planter in itself or, as here, a covering to hide a plastic pot. We have planted agapanthus because it likes its roots to be confined, does well in pots, is tolerant of neglect and flowers late in the season for a long period.

Right: We have combined a series of plantings to make a composition of foliage in shades of green. In the foreground, *Scleranthus biflorus*, a bright green, mound-forming perennial which, as it grows, creates an interesting sculptural shape. Behind it is *Hebe* 'Pewter Dome', one of my favourite grey and sculptural plants. The *Scleranthus* are planted in large machine-made terracotta pots painted dark green, and have been positioned so that they are framed by a low hedge of clipped box. I see this pair of pots as a scaled down version of Repton's idea of repoussoir trees framing a vista set in a larger landscape.

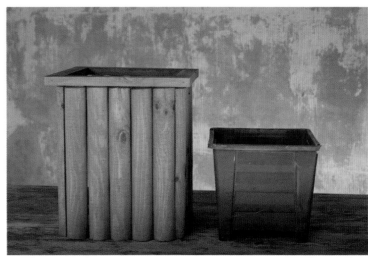

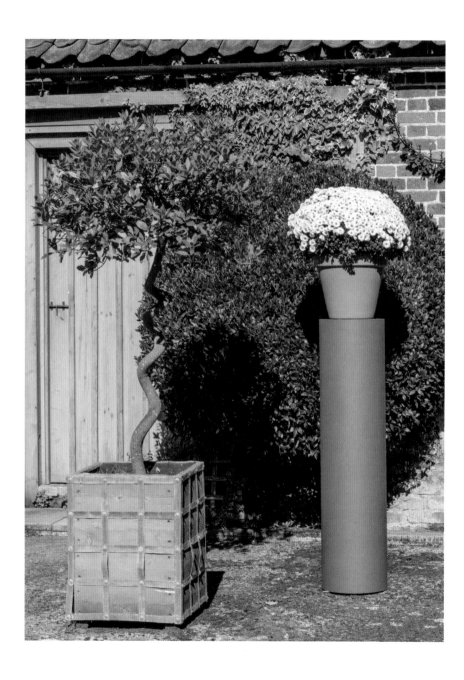

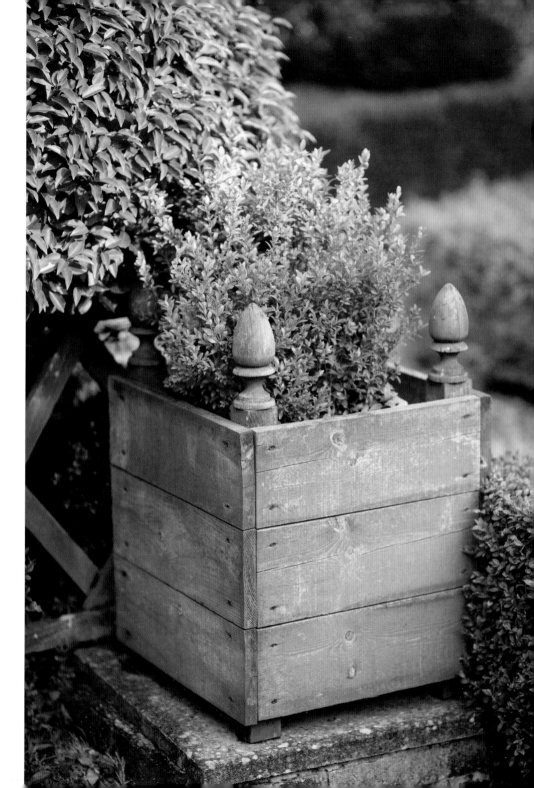

Here are two modern updates of the famous Versailles cases, named after the orange tree cases at the Palace of Versailles. The original cases were very large and designed so that the sides could be easily removed to allow for re-potting of the citrus trees. Those in my garden are far smaller – that on the far left is 25.5in (650mm) square, and on the left, 18in (450mm) square. Whatever the size, the important thing about a Versailles case is that it should be taller than it is wide – vertical height is what makes them elegant and too many of those that you find in garden centres are either square or, even worse, squat of square.

Far left and below right: A standard boarded Versailles case but with lead strips fixed with roofing clout nails, which gives the feeling of a ribbed cast lead cistern, which were reinforced like that between the 16th and 18th centuries. Lead has the added advantage of acquiring an instant patina when in contact with rainwater. Beside the wood and lead case is an example of plastic piping used as a type of column staging, raising a pot to another level – which would be useful perhaps in front of a window, or behind other plants. Painted in matt emulsion Sadolin 'Slate Grey' it works well with the foliage, wood and brick surroundings. A disc of ply needs to be fixed inside the pipe to support the pot at the right height.

Left: A Versailles case used as a cache-pot with a plastic pot inside it, which means that you can change the display on a regular basis over the seasons using plants with seasonal interest – perhaps bulbs or wallflowers in spring, lavender in summer and then box in winter. An alternative scheme might be to have topiary underplanted with white *Bacopa* a trailing annual, or a low herb such as thyme; double layers of plants in a pot require more plant food as one plant will take nutrition from the other. The case is stained Sadolin 'Smokey Blue'.

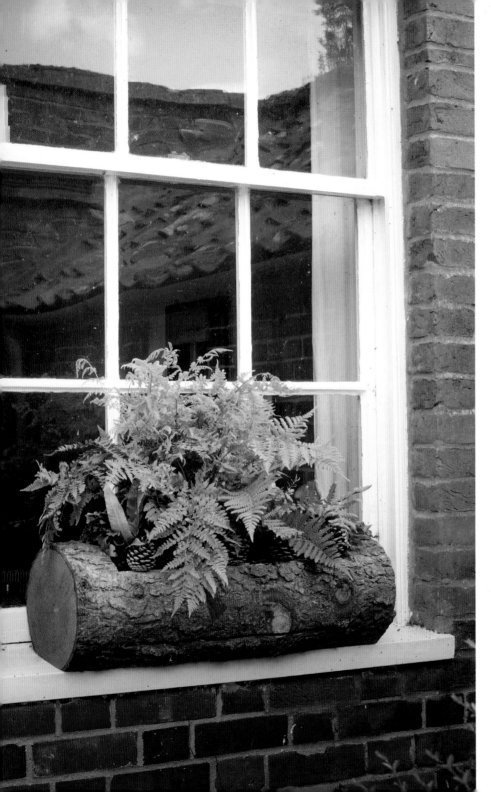

Don't despise the false rustic – it has always had a charm of its own.

Left and above: I have added to the rustic aesthetic of a ready-made log planter found at the local garden centre. The added dimension, which nods to the Regency fashion for admiring nature in the wild, but nature that had been partially tamed, are pine cones screwed to the front edge. It has been planted with ferns – appropriate for the early 19th century when ferns were becoming fashionable. Wooden planters like this are usually stained with ugly orange wood preservative, so I have stained the cut ends grey.

Right: In another version I have gilded the surface of the bark to give it a rich look. Dull red emulsion paint has been applied under the gilding to emulate the red bole that is usually the base beneath gilding; as an undercoat it gives richness to the final finish. I used Dutch metal leaf, rather than gold leaf, which comes in larger sheets and is easier to apply. It was put on over a tacky coat of gold size, which acts as an adhesive for the leaf. The worse you do it, the better it looks; a broken surface is far better than a smooth, too-perfect one. Add a coat of clear varnish over Dutch metal to delay tarnishing

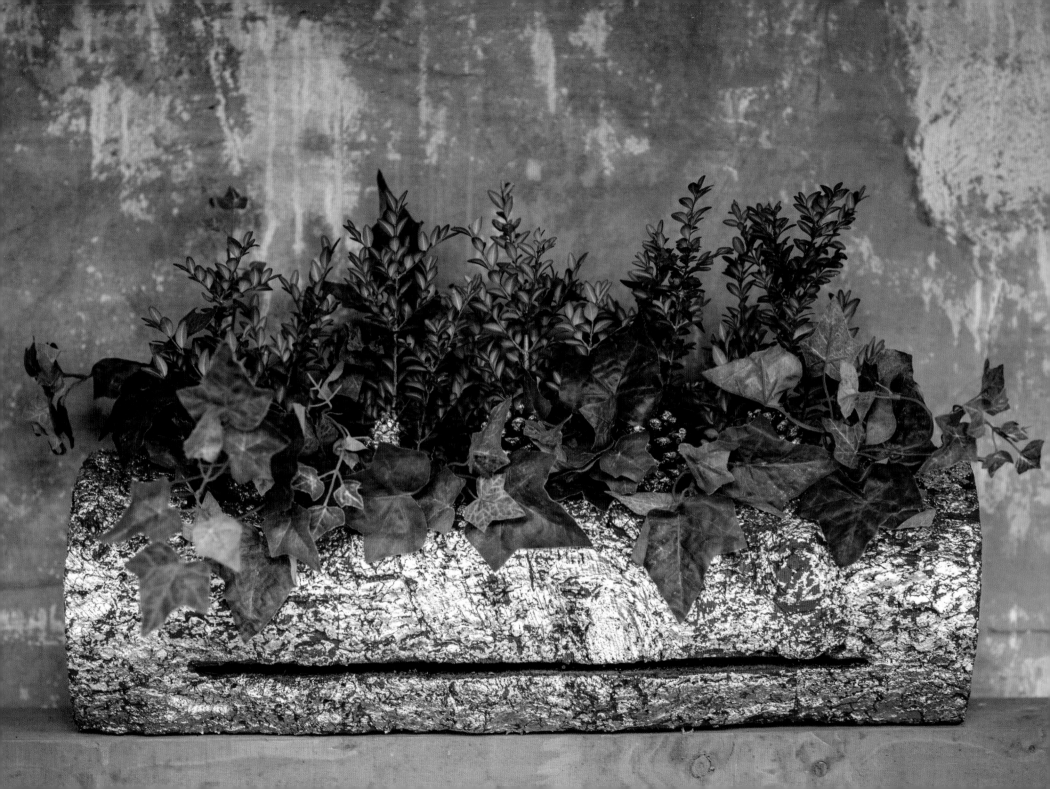

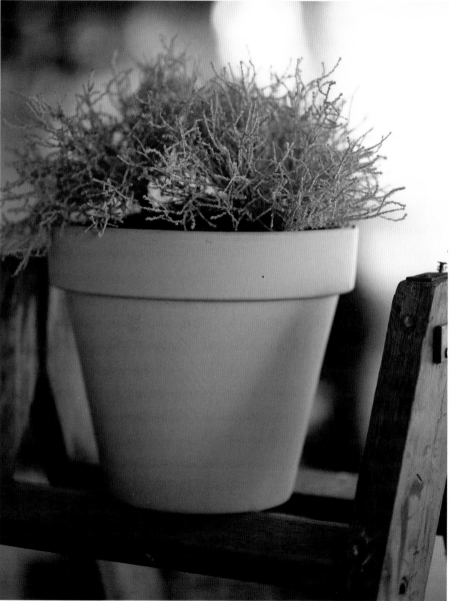

The traditional garden plant container was of course the turned terracotta pot – made in many different sizes and shapes for the growing of everything from flowers to strawberries and bulbs to rhubarb. You can still, at a price, find lovely hand-thrown terracotta pots, both antique and new, but much cheaper and far more widely obtainable are modern pressed pots, available everywhere, and found in a wide variety of sizes and shapes. With their unvarying colour and shape these can look a bit grim straight off the shelf, but there are ways to make them appear immediately nicer through patination and paint, and also through the way they are arranged and planted up. Artificial or dried plants work surprising well in a pot, particularly succulents or grey foliaged-plants.

Far left: The remains of paint was thinly applied, making the pot look almost as it had been buried and unearthed.

Centre left: A pot painted in Farrow & Ball 'Stoney Ground' has been filled with plastic *Calocephalus brownii* .

Left: A blue-painted pot is filled with sea lavender, which has a long life, even outdoors, as long as it is sheltered from rain.

This illustrates a simple way to paint modern machine-made pots by varying the colour and tone of each pot. A group of pots can be painted to match or in mixed but toning colours – look at the families of colour that are found together on domestic paint colour charts.

Left: Pick your preferred colour group and then buy sample pots of three, perhaps four, colours of matt emulsion. Particularly effective is to choose a colour scheme that relates to a season or time of year.

Right: We have planted spring bulbs and chosen spring-like paint colours to go with them. Rather than applying the paint carefully, it is better to be a bit haphazard, so that the surface is broken; even better is when some of the terracotta shows through, rather like the delightful effect of old buildings where the brick starts to show through the painted surface. Grouping is important – either in a close line on a bench or a series of pallets or low tables or, as on the right, on a ladder or plant staging. Look first at the planting and compose the foliage first, rather than the pots, looking at it in the same way that you would look at a border or indeed a larger landscape.

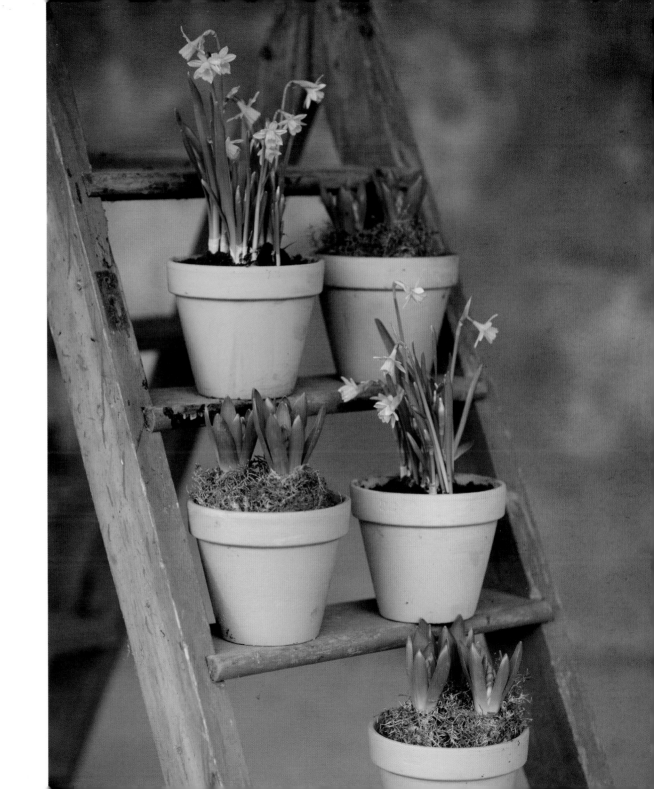

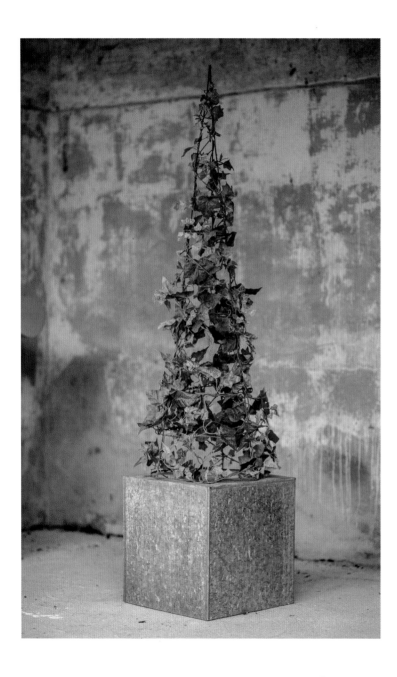

One trend that the garden centre has popularised has been the cubic pot, which, in a small space with no soil – like a balcony, for example – actually works very well as you can virtually create raised beds by putting the pots together. As a group they become invisible – part of the architecture. Our version, below left, is a galvanised steel container that has a huge amount of potential in container terms; it can be used not only by itself but also as an element of a larger scheme – either upside down, as we have done here, to show how, in a dark area with no possibility of real soil, to create a display of fake foliage – ivy on a topiary frame; or right side up, as a plain and self-effacing cache-pot.

Left: An alternative container/cache-pot is plastic pipe, which comes in many different sizes and which you can cut to size yourself. We have used a quite large pipe – 12in (30cm) in diameter – and although they come in dreary pipe-friendly colours like grey or brown, they can be painted as we have done here, in Dulux 'Cannon' – a deliberately low-key colour to set off the lively-foliaged and flowered hydrangea.

Right: In dark locations, do not despise fake foliage, as in some situations – a basement area, perhaps – it is the only thing that will give you a sense of green; ivy, used here, is particularly effective as the waxy leaves of the living plant have an artificial cast. On the painted barrel is a pâpier maché hanging-basket liner. The green in this picture is its original colour, but you could paint it a different, albeit low-key, tone.

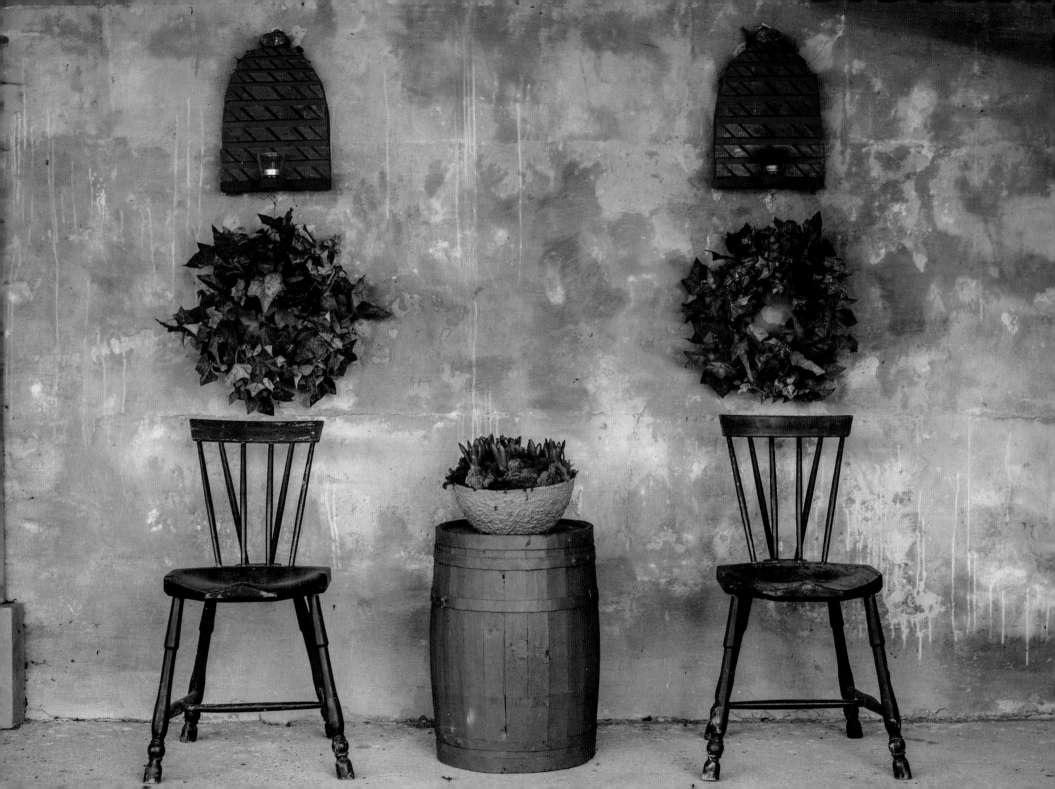

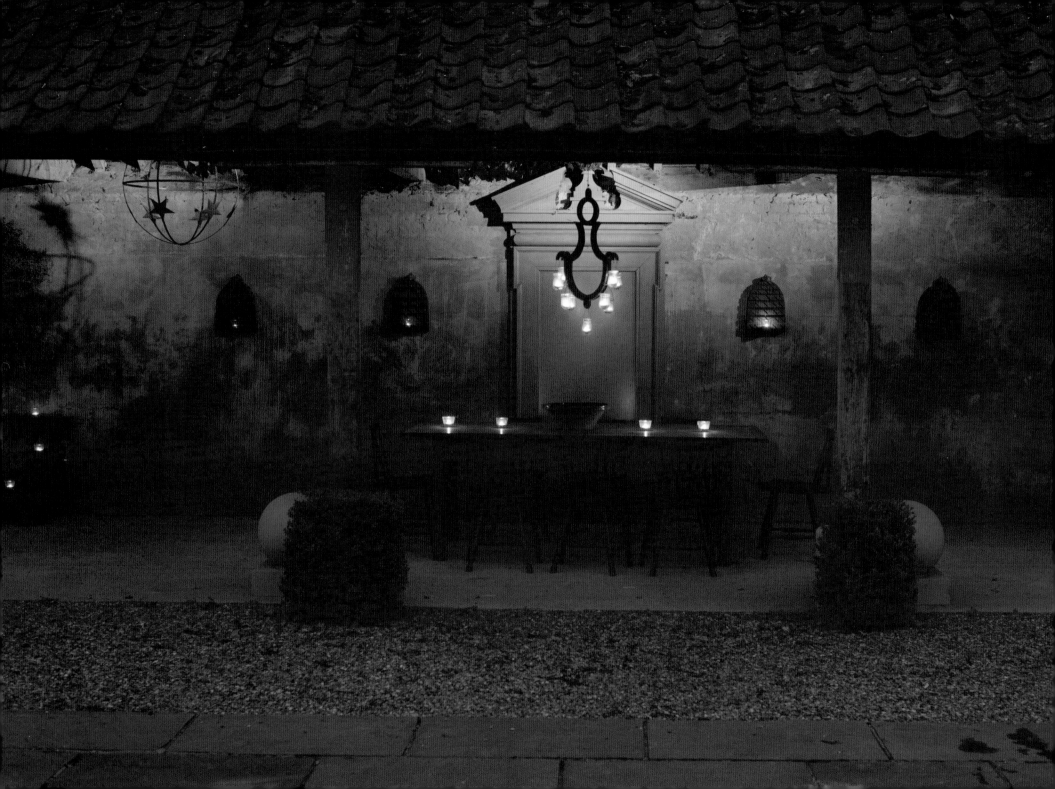

LIGHTING

Lighting makes a garden come to life at night; it gives atmosphere and transforms everything into something magical, and as the light source is in your control, you can make the garden look completely different from its daytime guise. Architecture, mouldings and plantings, too, will change the way they look: if you light from beneath – the exact reverse of daylight – the shadows that are produced will create their own drama. If you side-light you emphasise the form of any solid planting, while should you want to emphasise the silhouette of architectural plants with interestingly shaped leaves, back-lighting will throw them and the plant's skeletal structure into relief. In a small garden, lighting a feature like an arch can give a much greater sense of three dimensions to the space. At night you can also hide objects and whole backgrounds that you would rather were not there – simply by not lighting them – so only your own creations are visible. There is a far greater choice and variety of fittings today, and they do not have to be expensive; LED, Tungsten halogen and basic tungsten. For extra punch use spots such as Par 38 tungsten. Also, investigate solar lighting, which stores power by day and releases it at night; the range available

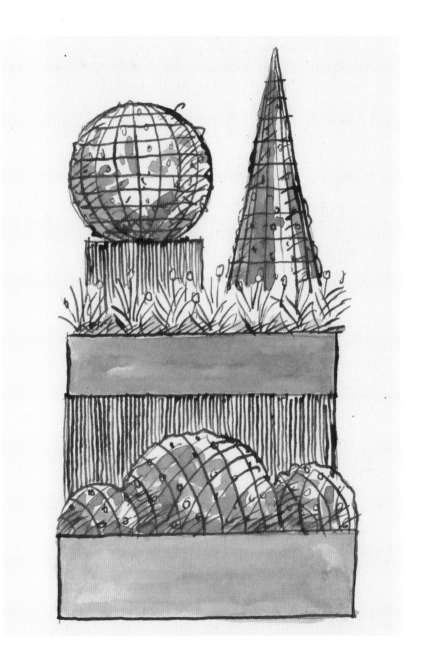

Pea lights attached to topiary frames or draped over topiary add sparkle to night-time planting.

has grown enormously, and their big advantage is that there is no need to worry about wiring to an electricity source. To get enough output and depth of light – particularly in town gardens where there is a lot of spilled light – I sometimes combine solar and battery lights with mains or low-voltage lighting. As with lighting inside the house, it is a good idea to have a range of lighting – broad-beamed spotlights and also small, runway-type lights (often sold as deck lights in garden centres). The colour range of LED garden lighting can vary from a very blue-white to a warm white that approximates to tungsten colour temperature – the colour I prefer, as it is warm looking and very different from daylight, which is quite blue in comparison. Whichever colour range you prefer, do not mix cold and warm together, as the final effect will be spotty and distracting.

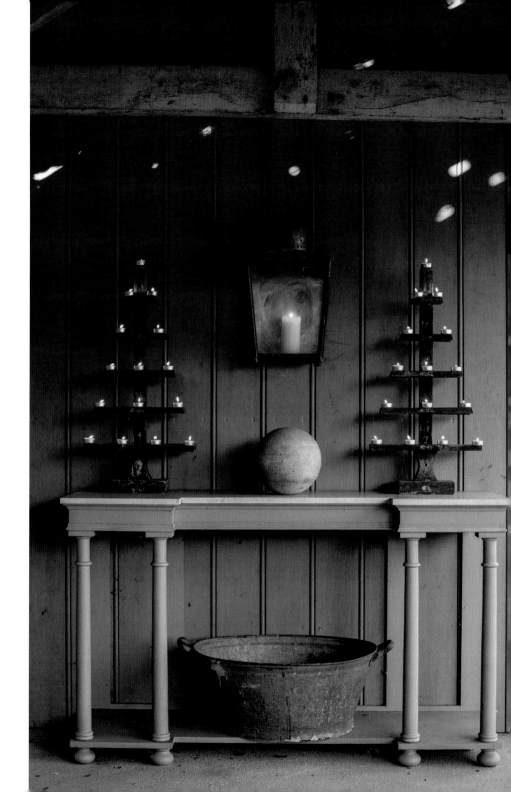

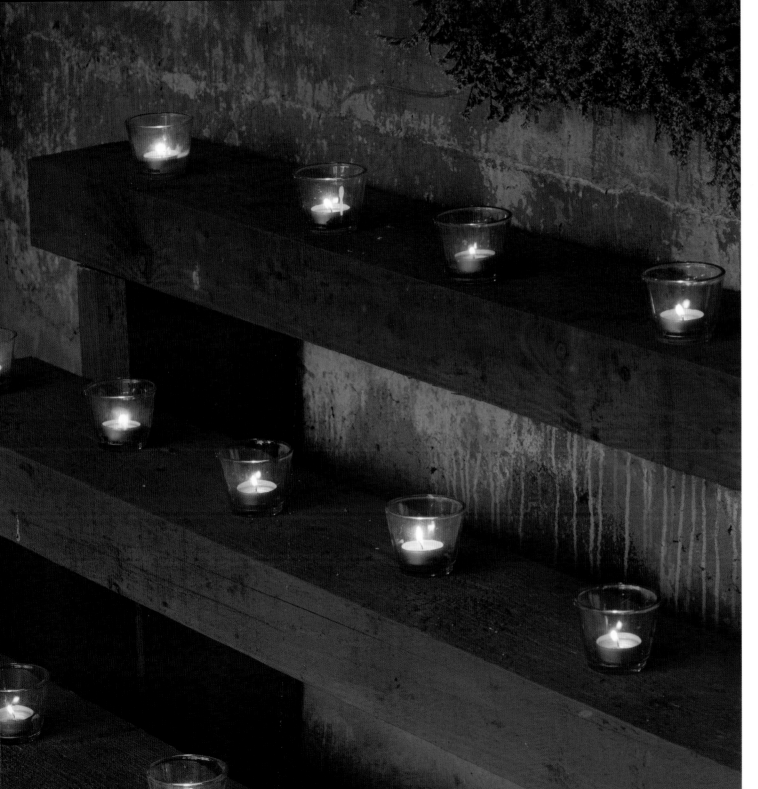

On one wall of an open barn I have put together several different low-key lighting arrangements.

Far left: A pair of very simple wooden candelabra, painted in Dulux 'Cannon', which are designed to have tealights spiked onto small nails protruding from horizontal wood laths. They are standing on a buffet painted with Farrow & Ball 'French Grey' – a good outdoor colour. Above them is an old wall lantern with a church candle inside. Galvanised tin lanterns in various shapes can be cheaply bought almost everywhere, and can benefit from a coat of matt emulsion – maybe red oxide or grey or black.

Left: Further along the same wall, on some staging I have made the simplest arrangement of tealights in contemporary versions of glass Vauxhall lights.

Lighting a garden with small spots of light has been popular in Britain since the 17th century, and particularly after the opening of the famous pleasure gardens at Vauxhall in London; by the middle of the 18th century Vauxhall was lit up in the evenings with up to 15,000 oil lights in small striated glass lamps, hung in the trees as well as being placed to follow the lines of arches and columns. The ones here are Victorian, but these charming jar-like lamps can be found in most garden centres today and are very effective when used to define architecture, paths and vistas. You can use any clear container for nightlights – for instance, jam jars – which will protect the flame from the wind. I have hung them from an outdoor wooden chandelier – see my sketch on the right of the different components and a similar idea for a wall sconce. The cut-out urn could be used as a baffle to hide a light source. I placed tea light candles inside the lamps, but you could use instead small battery-operated LED tea lights, which are now widely available and easy to obtain.

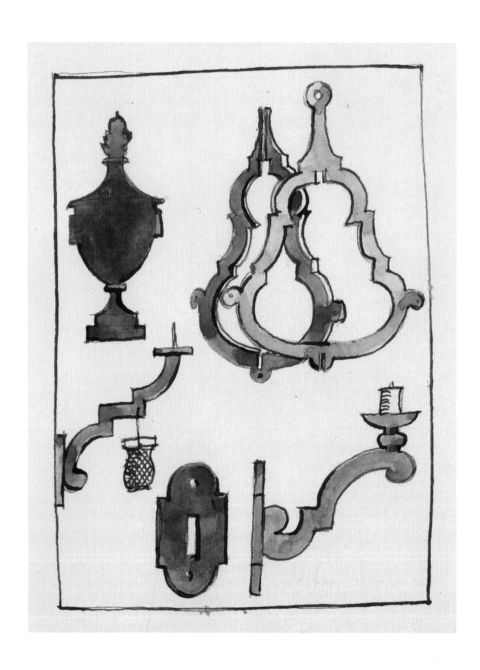

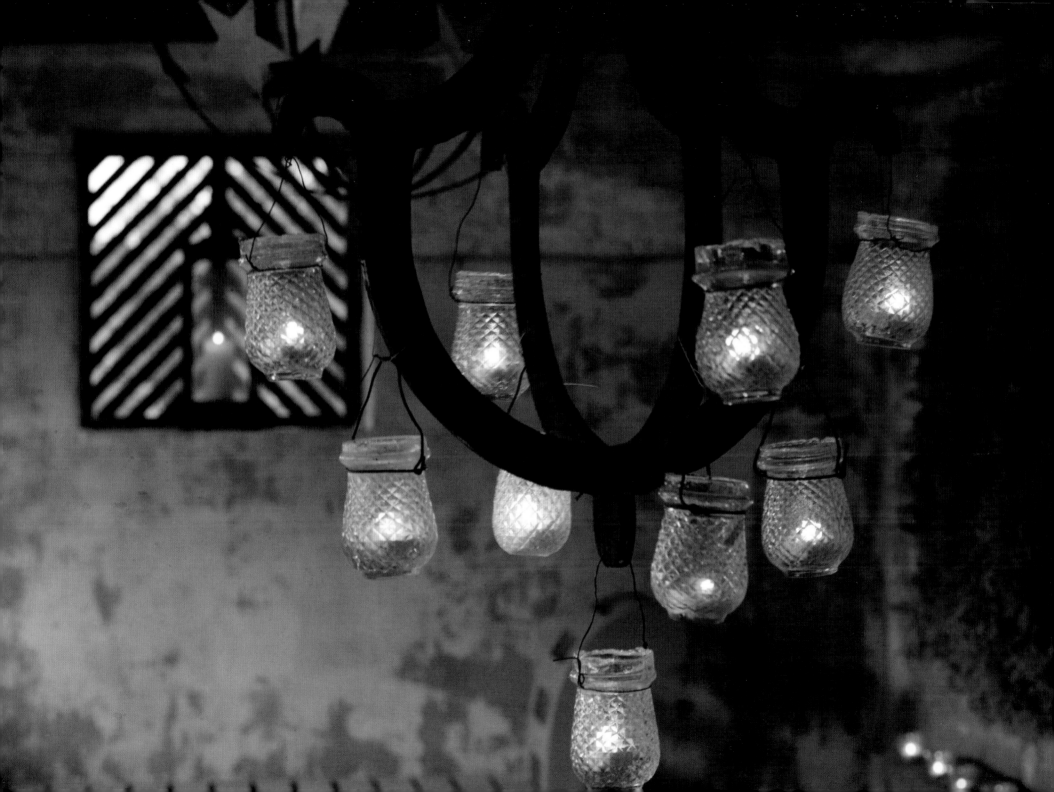

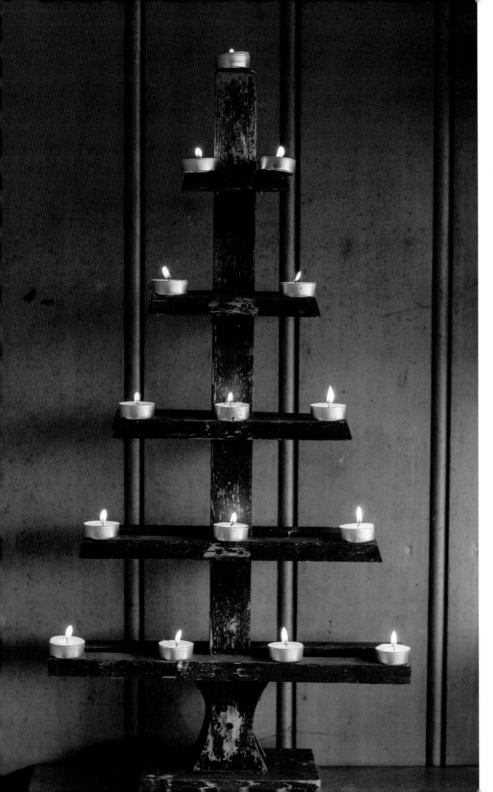

Left: A closer view of the simple candelabra structure seen on page 92, holding unmasked tealights.

Right: A Christmas star decoration is redeployed as an outdoor chandelier. Christmas decorations are, in fact, a good source of both garden lighting and general ornament for the garden all year round. Some companies bring out annual catalogues with ever more inventive and sophisticated decorative ideas, including clever designs for solar lighting, which can be used to highlight paths, to mark entrances or to emphasise trees or planting groups. In an open loggia (see page 109), halogen adjustable spots up-light into the roof void, which means that you get re-directed lighting downwards – a good way to get a fairly low-key effect in a space like this. As a general rule, you should never over-light, rather only use the minimum you need for visibility.

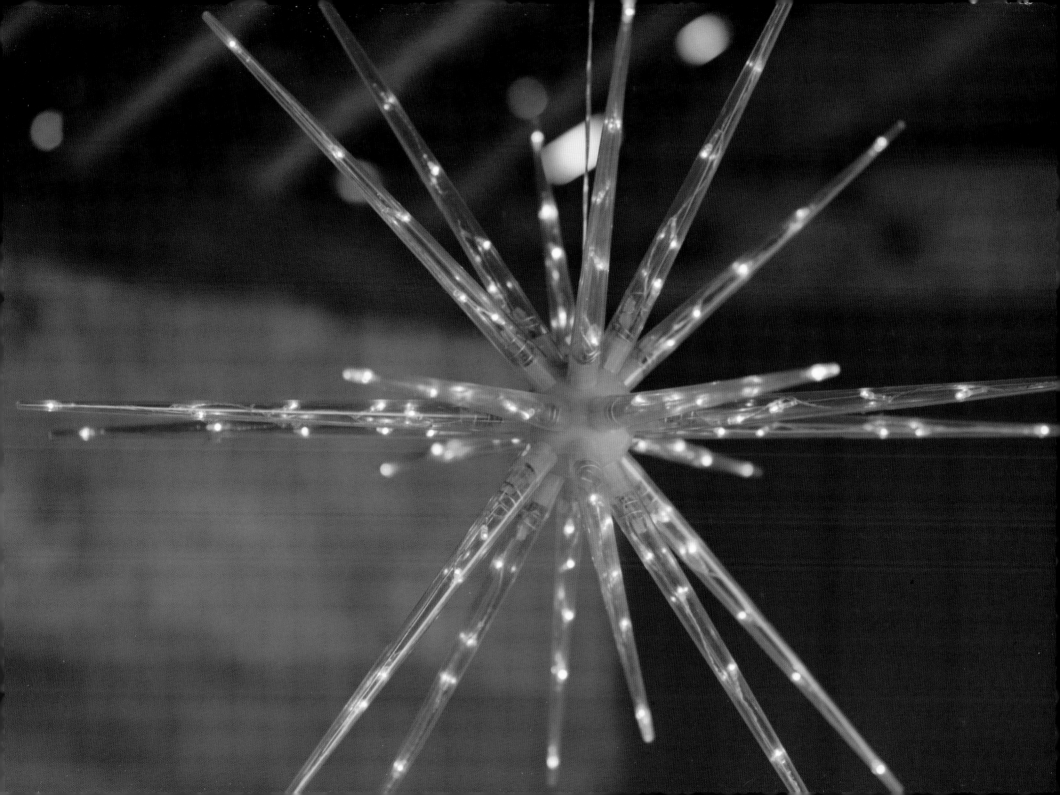

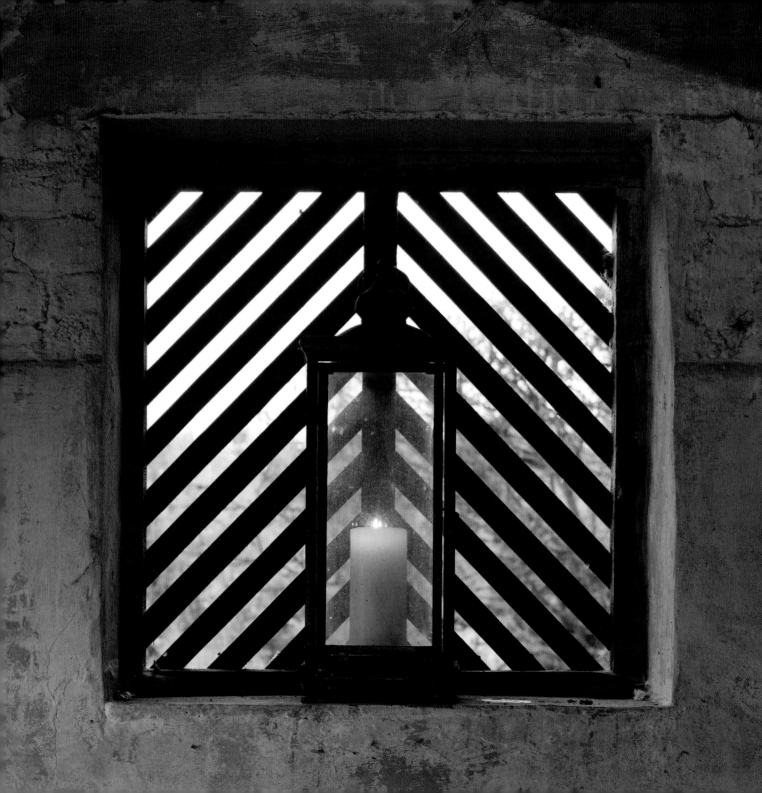

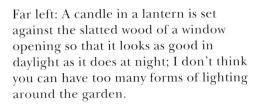

Far left: A candle in a lantern is set against the slatted wood of a window opening so that it looks as good in daylight as it does at night; I don't think you can have too many forms of lighting around the garden.

Left: Points of light can have a subtle effect. Here I have used two off-the-peg, hanging basket frames wired together, with solar pea lights wound through them to give a three-dimensional ball of light; the same effect could be achieved by draping nets of pea lights over three-dimensional objects (see sketch page 91). Look at solar light curtains in Christmas light catalogues.

There are many references to the theatre in gardens of the 17th century – not meaning that the garden was necessarily intended for theatrical performance, but rather referring to the slightly mysterious theatrical quality that was such an important element of gardens then. Some gardens used hedges and topiary to represent theatrical scenery, occasionally peopled with figures from the *Commedia dell'arte* in sculpture form.

Right: In my garden theatre the urns on plinths in these hornbeam arches against a background of *Cupressocyparis leylandii* are lit by simple spot lights hidden behind tin cowls so that you see the projected light but not the light source. These model the three dimensions of the urns and highlight them against the dark background of the hedge.

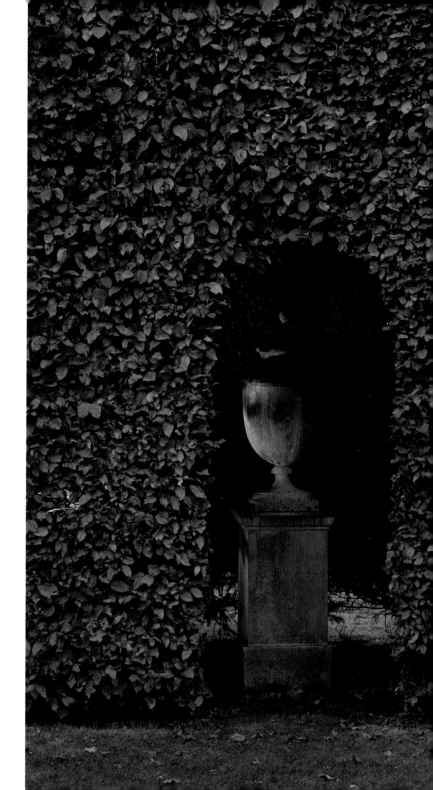

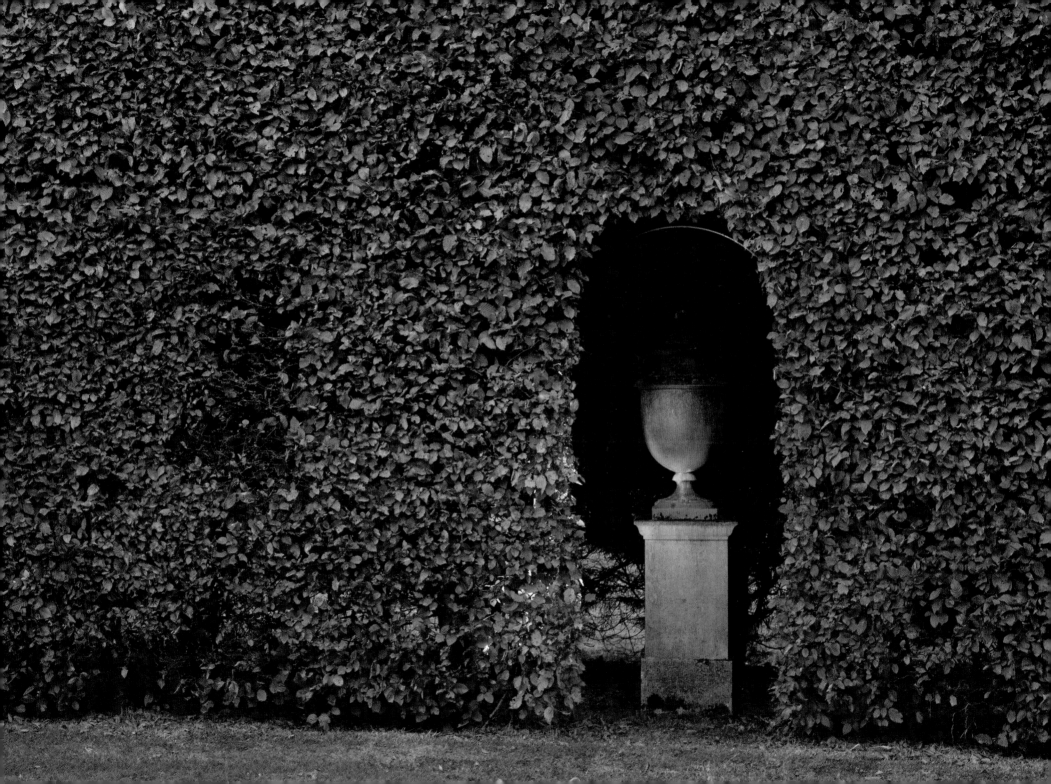

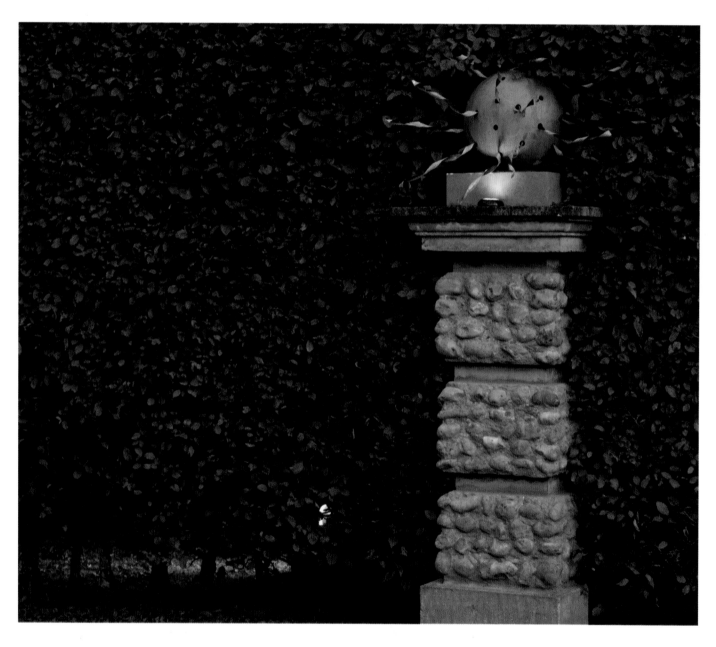

This is a modern interpretation of the Renaissance flaming ball – a popular device in gardens and architecture. This one was inspired by the original lightning conductors at Burghley House, a motif I re-used in the Garden of Surprises there. I drilled holes in a resin ball (you could use a rigid football painted a stone colour). For the flames I twisted pieces of copper, which are glued into the holes. They are internally lit by battery operated LED lights. They sit on home-made cast flint plinths that frame the entrance to the theatre garden.

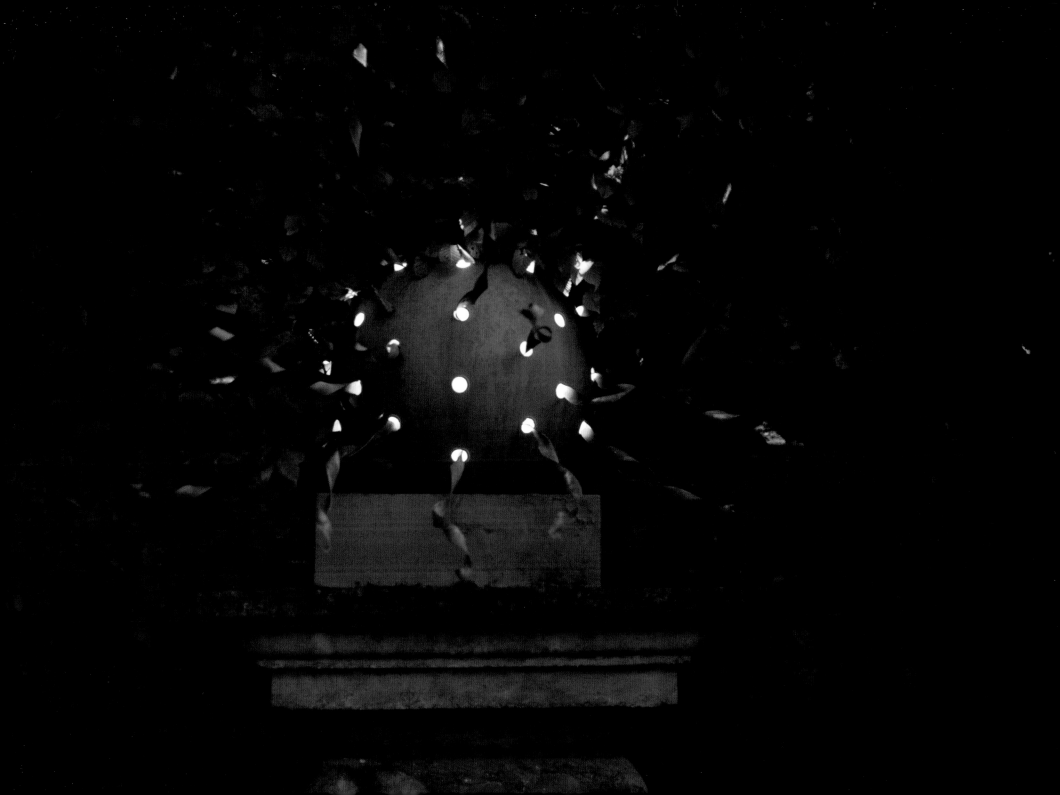

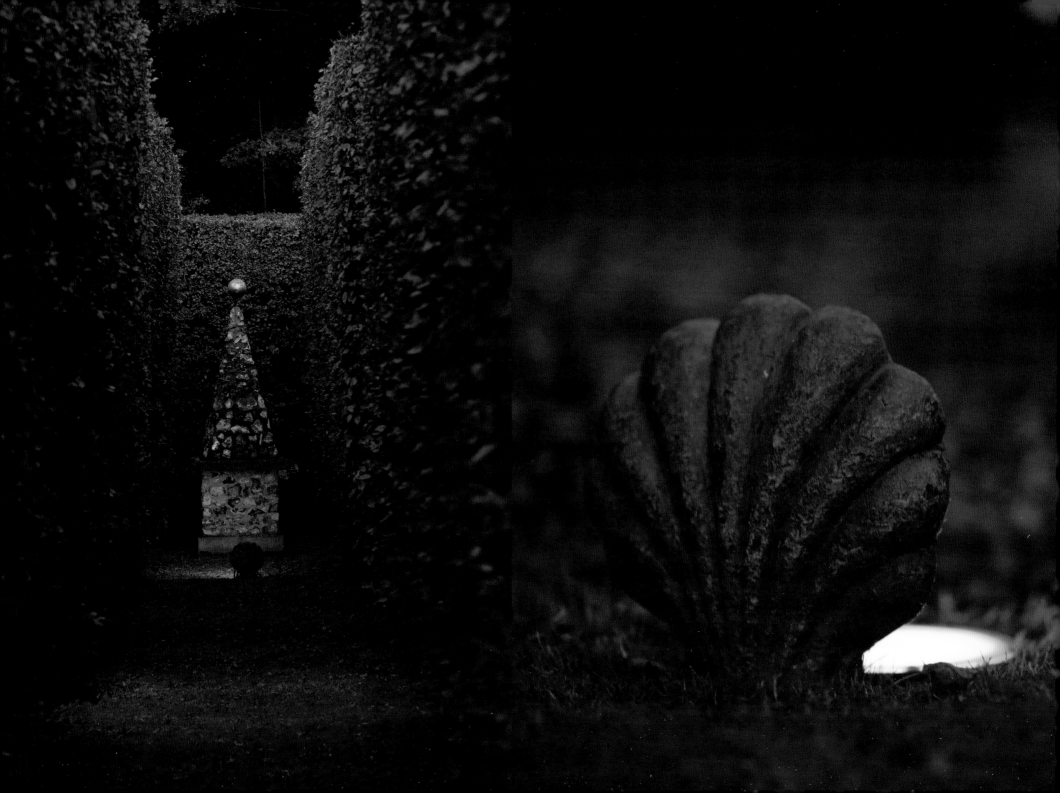

I wanted quite strong lighting here as the obelisk is some distance from the viewer; the lights themselves are very basic.

Far left: Part of the reason the lighting is so effective here is that we have created a long dark allée, which makes the lighting much more dramatic than it would be in an open space. An angleable Par 38 spot is hidden behind a shell cowl cast in concrete from a shell-shaped cake tin.

Right: A sketch of other effective cowl shapes that could be easily cut out of ply.

Left and far right: Round recessed can lights with ordinary 60w light bulbs uplight the flint obelisks. This light source is hidden by a cast lead shell on a metal spike. Placing them close to the obelisk highlights the knobbly flint surface.

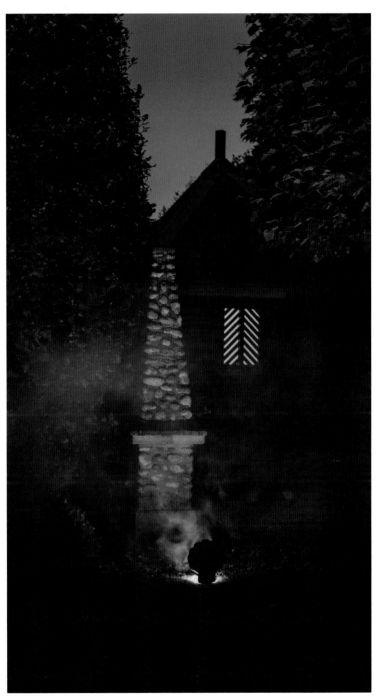

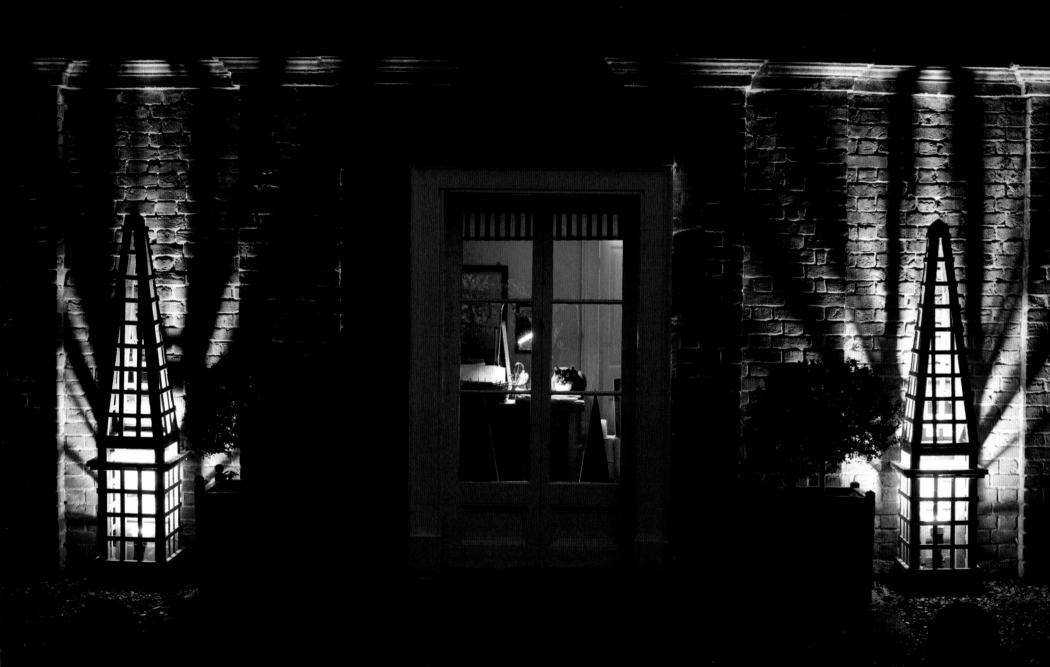

Left: The trellis obelisk, a simple shape in itself, is lit from within – a basic angleable PAR 38 spot casts strong shadows upon the wall of the house, creating both a serviceable entrance light as well as dramatic effect and an eye-catching announcement that this is where you should enter.

Right: The side-lit urns are made mysterious with artificial smoke from a smoke machine (which can be bought or hired – see internet specialists).

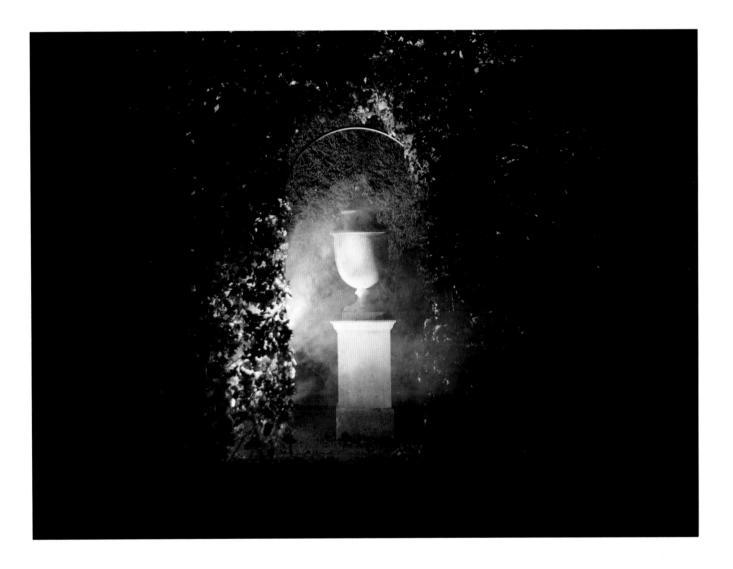

Across the pool into the loggia; with water you can hardly have too many lights – many simple light sources can have a very magical effect in a garden. Flood lights work in a broader context but for close-up effect, go for small points of light.

Right: We have layered the lights here, starting with a particularly simple effect in the pool, where we have floated some small LED ice cube lights, which light up in contact with water; they are designed to be used in drinks, but they can look good in larger stretches of water. Find them in local DIY and homeware stores – you could have as few or many as you chose.

Far right: Within the loggia the tiered Vauxhall lights are on staging, set into the simple chandelier or on brackets, and on the wall itself terracotta-painted wooden beehive brackets, originally part of a Noah's Ark, have been made to support lights – modern versions of wall sconces.

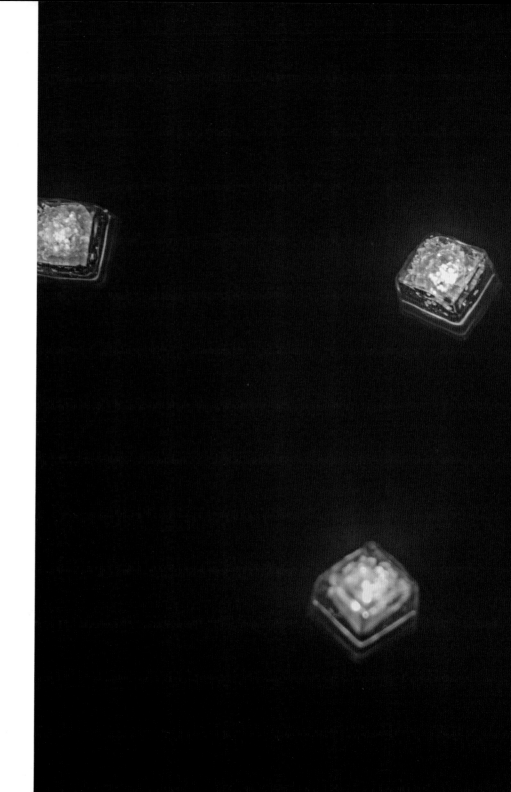

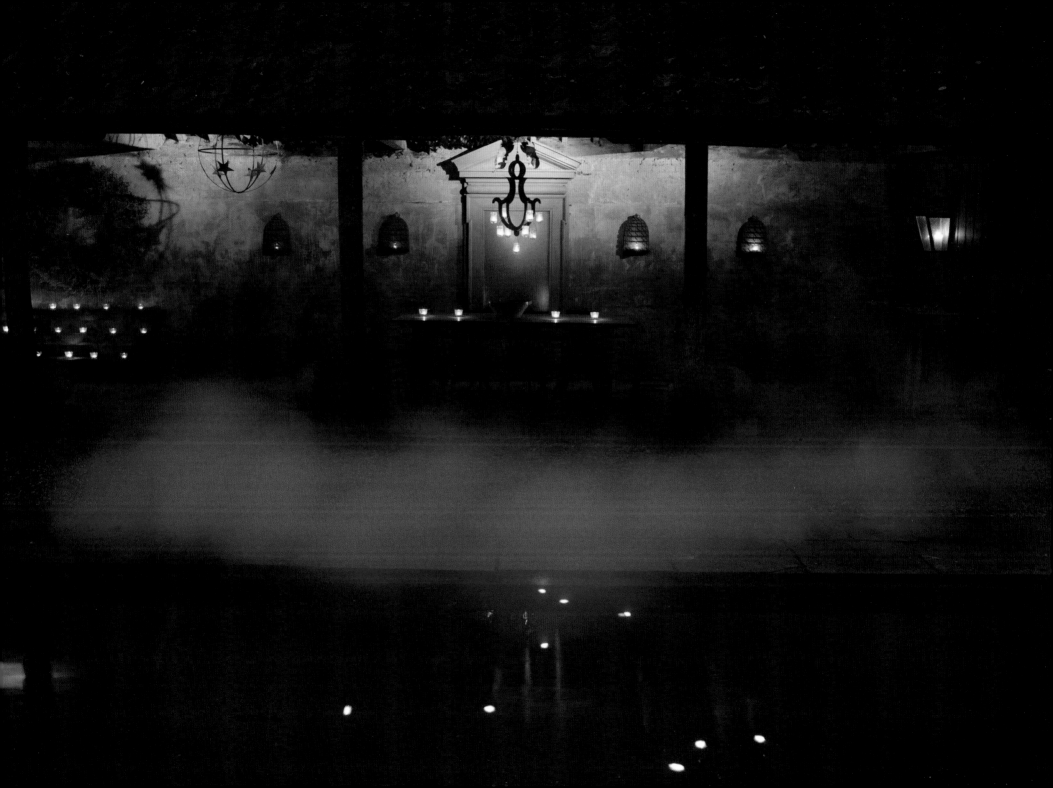

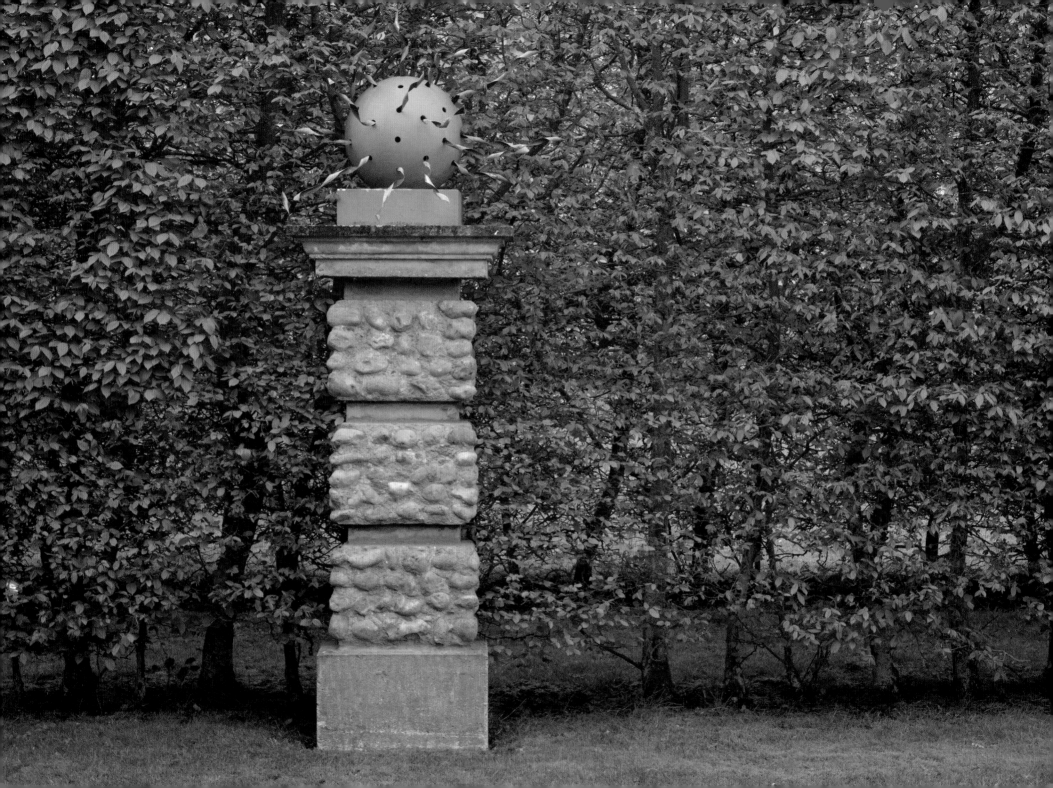

EMBELLISHMENTS

Ornament – from the largest pieces of sculpture to the smallest of decorative objects – has always been important, as essential in the garden as it is in the house. The 17th-century formal garden was perhaps the apogée of this, but there are few gardens, even today, that would not benefit from some form of ornament: as a view-stopper, a focal point or a framing device. Traditional ornament, from decorative urns to sculpture, from gates to furniture, can of course play an important part, but be open to inspiration from any quarter – nothing should be dismissed, for sometimes what might appear too kitsch or too ordinary may have hidden potential. With a bit of lateral thinking, and clever positioning, decorative objects – and, at first sight, not-so-decorative ones – play a useful and attractive role in gardens. Never, for example, pass up an opportunity to go into an ironmonger or hardware store – both at home and abroad – particularly an independent one, as there is often something that can be used in the garden, from galvanised buckets to floats for cisterns.

A concrete ball on a cast plinth makes enough of a statement in a very minimal trellis pergola with trellis sides. The important thing is that the scale is bold. If they are made of plain new concrete paint both parts a deep stone colour in matt emulsion – it saves having to wait for patina and the paint surface will weather in a satisfactory way.

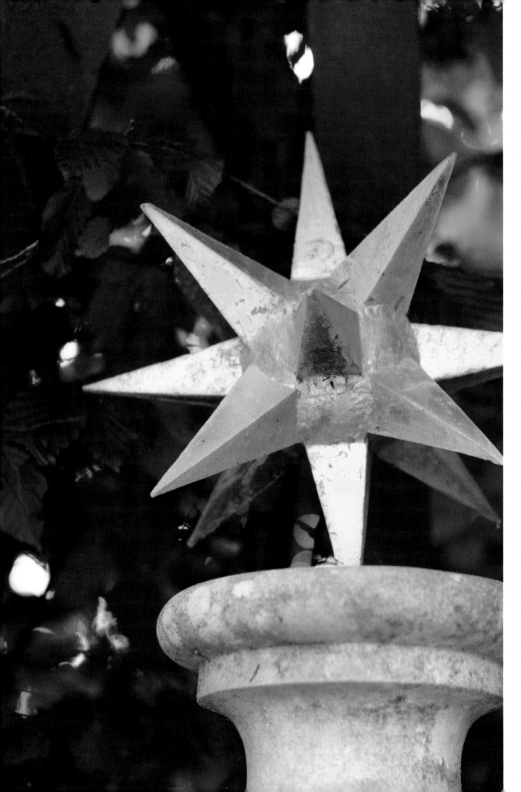
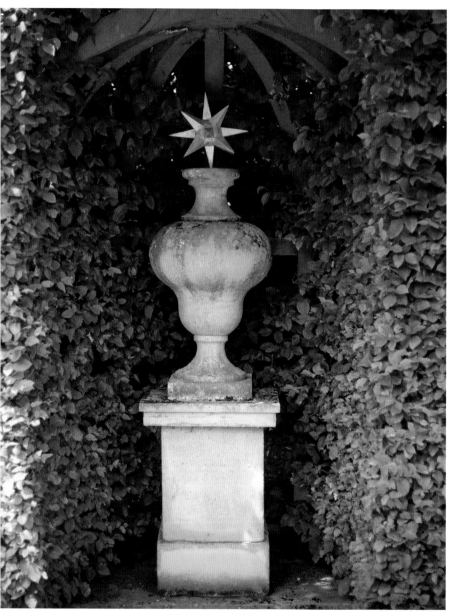

The image of a star is a constant in ornament and decoration.

Left: In my garden I have one in cast lead, on top of a cast stone urn, in a hornbeam niche, whose dark background throws the urn into relief.

Right: On top of a brick pier is a large lead urn with a large gilded star. The whole urn was cast by Brian Turner from an old model – its original coat of arms having been substituted by the star. It is my interpretation of what in the USA is known as a barn star, those large metal stars still seen on barns on the East Coast of America, some originally raised as a builder's mark, others added as a symbol of good fortune. They are still made today (see Directory page 123) and could be gainfully employed in any garden on a wall, set into a hedge or attached to a garden building.

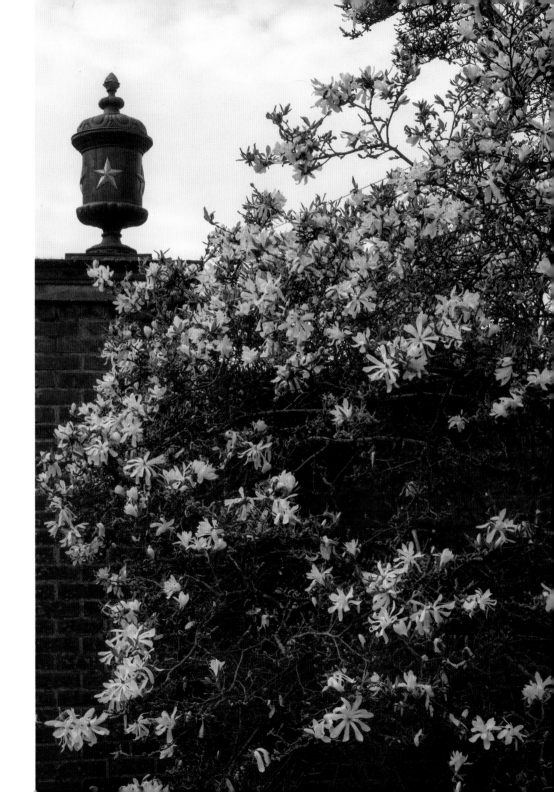

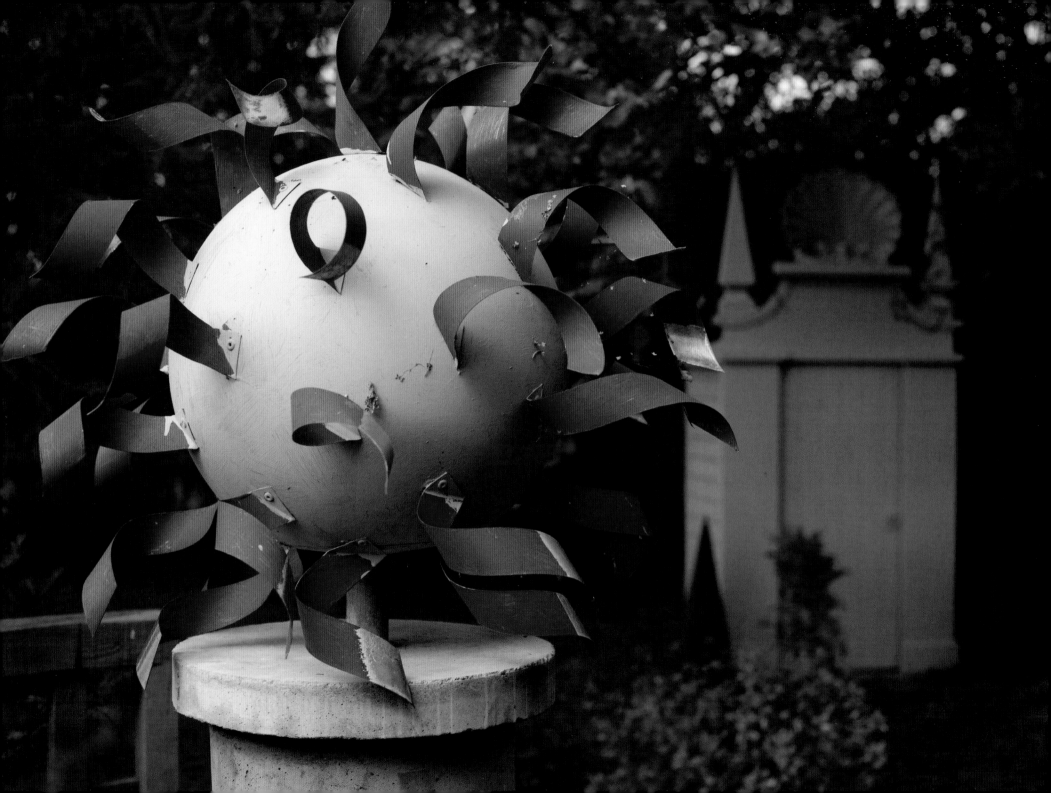

Left: Another way to make this flaming ball (see pages 102–3) might be to use a stainless steel hollow ball, which you can buy in a variety of sizes from many garden centres. I drilled small holes into it and pop-rivetted curled, copper strips to it (you could also use galvanised steel strips and could gild them totally for a more fiery effect). This one stands on a post that is concrete cast from a plastic pipe, but there is no reason why you should not use the plastic pipe itself and paint it, as we have done on page 88.

Right: The lead icicles on this fountain are a re-working of 17th-century frost-work, much used to give a dribbling, grotto-like effect around water. This could be done more simply by cutting out lead sheet into irregular zig-zags and nailing them to the edge of a hardwood disc. The golden globe fountain finial is a gilded copper float, more usually seen in a lavatory cistern. Incidentally, in Spain you can still find, at plumbers' suppliers, brass floats which look very good on posts, as finials or topping trellis work piers or obelisks. Modern plastic ones painted or gilded can also be used in the same way.

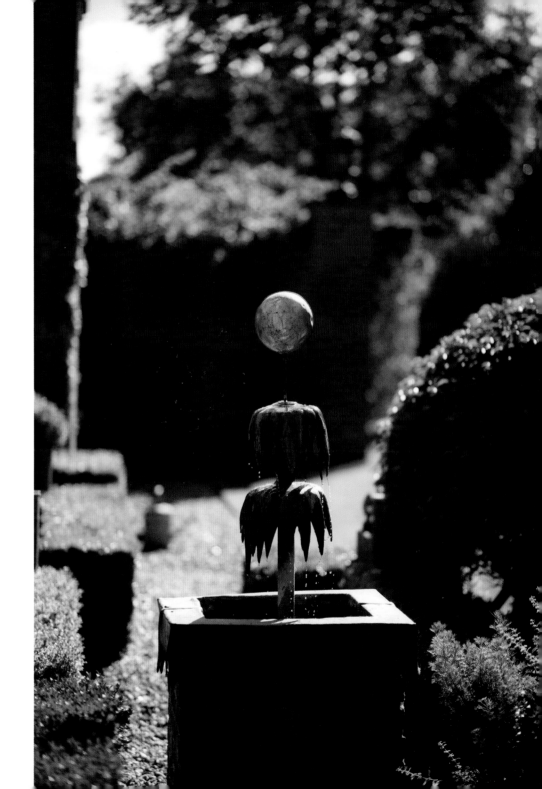

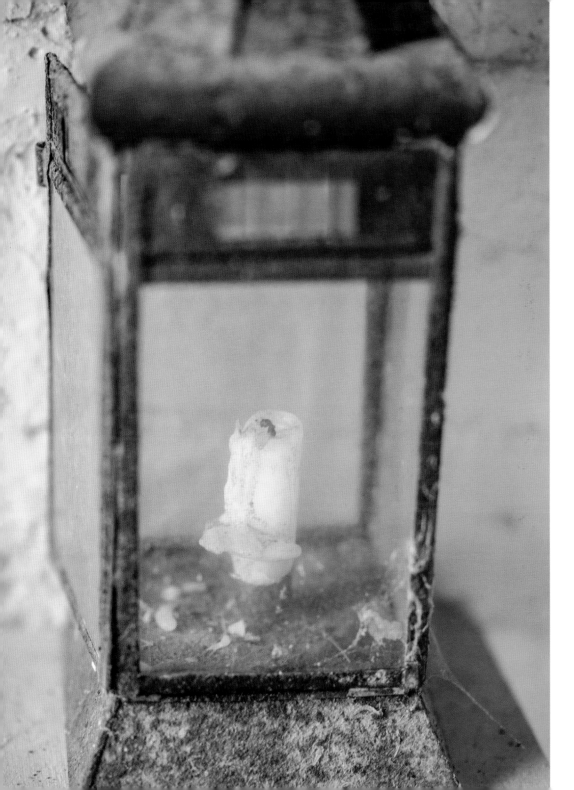

Both these pieces – a nice old rusted lantern and a distressed gilded globe – are from architectural salvage companies. These are always good hunting grounds and there are many to choose from; the globe was once on the roof of Sea Container House on the London South Embankment. Do not discount using found, ornamental objects on a very large, even grand scale – they will often work remarkably well in even small gardens; giant urns in a small garden can look very effective.

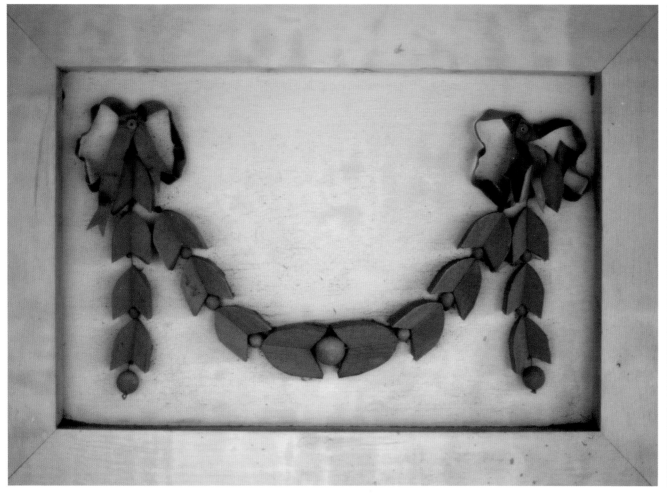

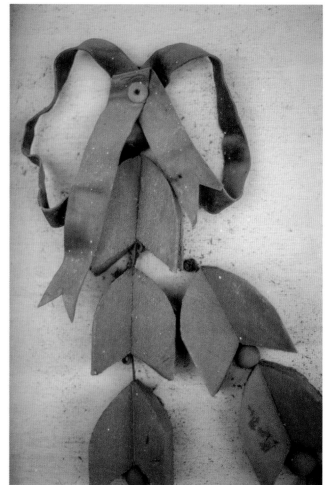

Left: Since antiquity, the festoon has
been a favourite decorative device – it
seems to convey a sense of welcome.
I made this classical festoon design
by using a jigsaw to cut a triangular
section of wood into husk shapes of
varying sizes; they are strung onto wire
with small ball finials at each end, and
with ribbons of thin strips of lead,
from which they appear to hang. The
whole festoon is painted verdigris
green against a background of stone
colour. A festoon needn't necessarily be
made of wood – fir cones with turned
balls of varying sizes would work very
well, or even linked pieces of plastic
fruit (widely available) glued together,
spray-painted grey or stone colour to
homogenise the disparate fruits – very
Grinling Gibbons!

Right: A small bronze sculpture by
Elizabeth Tate on a post, demonstrating
the opposite effect to using over-scaled
pieces; a small piece can work very well
as long as it is displayed in a way that
gives it presence – this one is sited in its
own semi-circle of yew.

Right: This terracotta bust, seen earlier in the book, has been placed so that it is framed by green beech, which forms the back wall of an open trellis pavilion – a good way to frame an ornament and give it importance.

Far right: This apple ornament – shown on a post – has actually has been cast in lead from a real apple, but there is no reason why you couldn't paint plastic apples in lead tones, or even gild them – as I did for a recent garden where we recreated a silver bowl of fruit taken from a description of a masque at Kenilworth for Elizabeth I. The apple is another example of how small things and natural objects – shells, pine cones, even artificial fruit, possibly painted to give them sculptural dimension – when suitably set, add interest and detail to a small garden.

Right: This is my reworked version of a trophy – a decorative piece, favoured by the Ancients, and originally constructed from weapons and military paraphernalia; since then, the idea has been repeated as a decorative device, based on many themes, from musical instruments to theatrical masks and in fact all sorts of tools of a trade or objects emblematic of a theme. I constructed this trophy by attaching a selection of garden tools, all painted in the same colour, to a backboard in the form of a fabric swag, and bolting or screwing together several shafts and handles to make an irregular assemblage - varied sizes and shapes work better than tools or objects of similar size and shape. A simpler version would not be too difficult to make and could be attached to an outside wall, where it would be most effective.

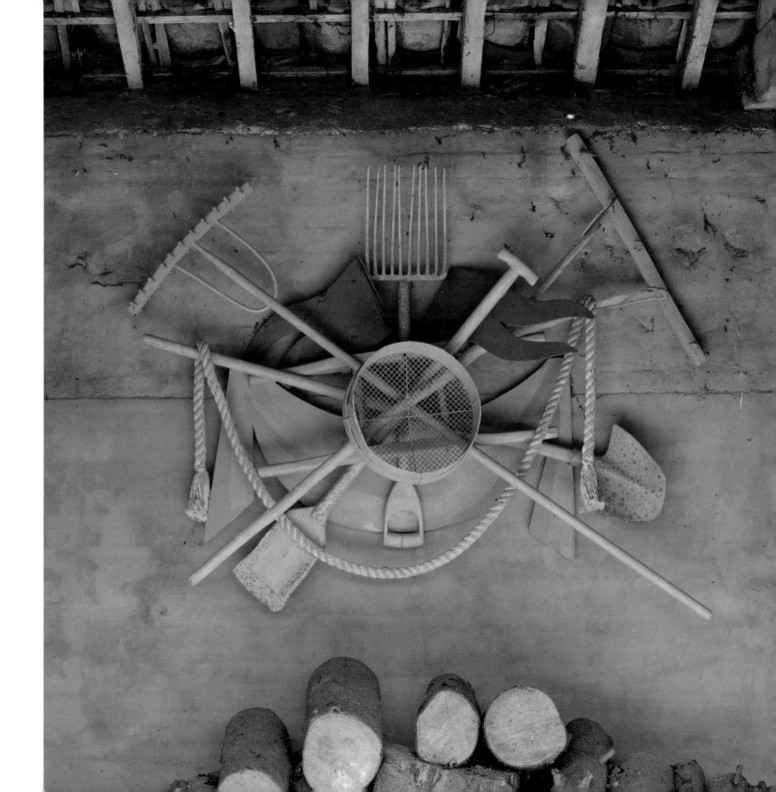

DIRECTORY

George Carter Garden Design
grcarter@easynet.co.uk
www.georgecarter
gardens.co.uk

Antique and Vintage
Mabel and Rose
www.mabelandrose.co.uk
*Vintage buckets, crates, boxes, bins,
tin baths and wheelbarrows*

Architectural Salvage
For dealers in the UK go to Salvo
www.salvo.co.uk
*Online directory of architectural salvage
and reclamation businesses*

Barn Stars
— UK
At The Ark
www.attheark.co.uk

Vintage Amish barn stars
Not On The High Street
www.notonthehighstreet.com
New Amish barn stars

— US
Dirty Pretty Vintage
www.dirtyprettyvintage.com

Pine Ridge Online
www.pineridgeonline.com

Amish Wares
www.amishwares.com

Christmas Lights and Decorations
Noma Lighting
www.noma.co.uk
Battery, solar, LED lights

Containers
The Pot Co
sales@thepotcompany.co.uk
www.thepotco.com

Jardins du Roi Soleil
www.jardinsduroisoleil.com

Superior Versailles cases
Hardwood Versailles Cases
www.jardinieres.net

**Independent Ironmongers
and Hardware Stockists**
— UK
Ipswich, Suffolk
Partridges
www.partridgeshadleigh.co.uk

Modbury, Devon
Pickles
www.picklesmodbry.co.uk

Cockermouth, Cumbria
Firn's
www.firns.co.uk

Glasgow
Crocket
www.crockets.co.uk

— US
The North American Retail Hardware
Association (NRHA)
www.nrha.org
*Has details of independent hardware
stores*

Flint Blocks
South Down
Flints
www.flintblocks.com
01273 959 199
*Concrete blocks with pieces of flint
inserted*

All Brick and Stone
www.allbrickandstone.com
01189 798 899
Loose flint and flint block

Furniture
Ikea
www.ikea.com

Windsor chairs for painting –
charity shops, junk shops

Garden Centres
B&Q
www.diy.com

Homebase
www.homebase.co.uk

CED
www.ced.ltd.uk
Stone supplies
The Chelsea Gardener
www.chelseagardener.com

The Romantic Garden Nursery
www.romantic-garden-nursery.co.uk
01603 261488

Gilding Suppliers
Cornelissen and Son
105a Great Russell Street
London WC1B
www.cornelissen.com

Green & Stone
259 King's Road
London SW3 5EL
www.greenandstone.com

Gold Leaf Supplies
www.goldleafsupplies.co.uk
01656 720566

Hurdles
English Hurdle
Taunton, Somerset
www.englishhurdle.co.uk

David Downie
www.hurdlemaker.co.uk

Leadwork
Brian Turner Leadwork
www.brianturner.co.uk
01263 860425
*Sheet lead is available by the roll from
most builders' merchants*

Lighting
Nomalite
www.noma.co.uk
Pea lights

Mr Light
www.mrlight.co.uk

Ryness
www.ryness.co.uk

Materials and Tools
B&Q
www.diy.com

Homebase
www.homebase.co.uk

Nurseries
Creake Plant Centre
www.creakeplantcentre.co.uk
01328 823018

Norfolk Herbs
www.norfolkherbs.co.uk
01362 860812

Architectural Plants
www.architecturalplants.com
01403 891772

Paint and Wood Stains
Sadolin
www.sadolin.co.uk
Wide range of paints and stains

Farrow & Ball
www.farrow-ball.com
*High quality paints in a variety of finishes
and subtle colours*

Sandtex
www.sandtex.co.uk
Exterior oil-bound eggshell paints

Plastic Pipe
Wickes
www.wickes.co.uk
Or other builders' suppliers

Specialist Shops
Birdie Fortescue
The Warehouse
North Street
Burnham Market, Norfolk PE32 8HG
www.birdiefortescue.co.uk
Has a selection of George Carter designs

Alpha Structures
www.alphastructures.co.uk
01580 852767
*Produce urns and other ornaments
to George Carter's designs*

Terracotta Pots
Italian Terrace Pots
www.italianterrace.co.uk 01284 789666
Superior handmade pots

Whichford Pottery
www.whichfordpottery.com
01608 684416
*Superior handmade pots
Machine-made pots are available from
most garden centres*

Trellis and Screening
Garden Supplies
www.gardensupplies.co.uk
Heather and brushwood screening

Homebase and B&Q
Trellis

Burnham Willow
www.burnhamwillow.co.uk
Woven willow and hazel fencing

Wirework Frames
DZD Ltd
www.dzd.co.uk

Garden Requisites
www.garden-requisites.co.uk

INDEX